# THE GOLDEN AGE OF COACHING AND SPORT

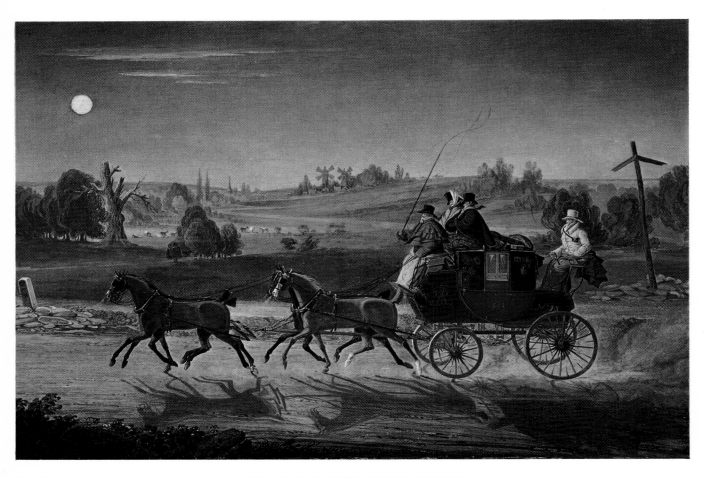

Cat. No. 14         THE MAIL COACH BY MOONLIGHT         20 × 30 in.

*In the possession of Mr. N. C. Selway*

*N. C. SELWAY*

# THE GOLDEN AGE OF COACHING AND SPORT

*As Depicted by James Pollard*

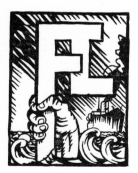

## F. LEWIS, PUBLISHERS, LIMITED

Publishers by appointment to the late Queen Mary

### LEIGH-ON-SEA

PRINTED AND MADE IN ENGLAND

©
COPYRIGHT BY

F. LEWIS, PUBLISHERS, LIMITED
THE TITHE HOUSE
LEIGH-ON-SEA, ENGLAND

SBN 85317 012 6

First published 1972

PRODUCED FOR AND UNDER THE SUPERVISION OF THE PUBLISHER AT
DAEDALUS PRESS, STOKE FERRY, KING'S LYNN, NORFOLK

# TABLE OF CONTENTS

# ACKNOWLEDGEMENTS

THE AUTHOR wishes to acknowledge his indebtedness to the following for the various forms of help they have given in the compilation of this book: Mr. F. L. Wilder, of Sotheby's; Mr. A. L. Gates, of Messrs. Ackermann & Son, London; the late Mr. E. J. Rousuck, of Messrs. Wildenstein & Co., New York; Mr. R. Van den Straeten, of the Van der Straeten Gallery, New York; Messrs. Knoedler & Co.; Mr. J. E. Fiddes of The Incurable Collector Inc., New York; Mr. Hugh Leggatt, of Messrs. Leggatt Brothers; Messrs. Thomas Agnew & Sons; Messrs. F. T. Sabin & Co.; Messrs. Gooden & Fox; Messrs. Pawsey & Payne; Mr. C. Marshall Spink; Mr. Richard Green; Mr. Edward Speelman; Messrs. Christie, Manson & Woods; Messrs. Sotheby's and The Parke-Bernet Galleries Inc., of New York; the Officials of the Print Room, British Museum; the Witt Library of the Courtauld Institute of Art; The Frick Reference Library of New York; and The Staff of the Paul Mellon Collection, Upperville, Virginia, USA.

# INTRODUCTION

THE MAIL COACH, journeying to the farthest corners of the country, had already become a familiar and romantic sight to Londoners by the time James Pollard was born in 1792, and his boyhood at Islington, spent in close proximity to the great Mail route to the North, must have fired his ambition early in life to paint coaching scenes.

More than any other artist, he brings to life the great days of the coaching era, for he lived and painted throughout the peak of this period from the time of Waterloo to the coming of the railways. His contemporary impressions portray vividly the thriving industry of Stage and Mail, The Inn and The Posting House. Nor were his talents confined to The Road, for he acquired sufficient knowledge of all field sports to earn a place in the front rank of the sporting artists of the day, and his racecourse scenes in particular have left a valuable record of the racing and steeplechasing of Regency days.

His father, Robert Pollard, had come south to London from Newcastle-on-Tyne in 1774, aged 19, and in 1778 married Miss Ann Iley, of the same city. In Newcastle, the Pollards were a family of some substance and a history of the city, published in 1827, refers to 'Robert the engraver, brother to Joseph Pollard of Newcastle, corn merchant'. Robert, as a boy, was bound apprentice to John Kirkup, a silversmith in Newcastle, but soon afterwards, on coming to London, became a pupil of Richard Wilson, R.A. He practised for a short time as a landscape and marine painter, and then was engaged for a term of years to learn engraving with Isaac Taylor of Holborn, eventually establishing himself in Islington as an engraver and print publisher.

Here, over the years, he produced a variety of engravings, in a style which was a mixture of line, etching and aquatint. Among the better known were his series of London Squares, and a number of sporting prints, for which there has always been considerable demand. Robert Pollard, a name much respected by later generations of his family, was known as a kind and generous man, always willing to help the struggling members of his own profession. When John Scott, twenty years his junior, came down from Newcastle to seek his fortune, Robert Pollard befriended him, and took him into business, later having the satisfaction of seeing his protégé achieve fame as an outstanding engraver of sporting prints.

He took an active part in business affairs, being a founder of the Artists' Benevolent Fund, and becoming a Director of the Incorporated Society of Artists, the forerunner of the Royal Academy. In 1791 this Society became extinct, and many years afterwards, in 1836, when he was aged 81, Robert Pollard, as the only surviving member, placed the charter, books and papers in the custody of the Academy. He died in Islington, where he had spent all his working life, in 1838, and was buried in Hornsey Churchyard. The headstone on the family grave records that he was 'Universally Respected'.

His portrait in the National Portrait Gallery shows him as an elegantly dressed, good-looking young man, and the inscription reads:

> Robert Pollard, artist and engraver.
> Executed the drawing of the Trial.
> of Warren Hastings in Westminster Hall.
> Painted in 1784 by Richard Samuel.

Robert Pollard's family consisted of five daughters and two sons, William and James; William was the elder of the two sons by six years and, although not an artist, was employed in his father's print publishing business. Although a son, 'Robert' is sometimes mentioned by art historians as having assisted his father, there is, in fact, no trace of such a son in the family records.

James was the youngest in the family. His father apparently made up his mind early that the boy should become a painter, and a series of letters* written by Robert Pollard to his boyhood friend at Newcastle, Thomas Bewick, the wood engraver, throw some interesting light on James Pollard's artistic upbringing.

It was Bewick who first fired Robert Pollard's interest in engraving, and a close and intimate relationship had followed.

In 1807, in the first of the letters, when the young Pollard was fifteen years of age, his father suggested to Bewick that he would like him to see 'James's pictures of horses after Ben Marshall, as I am trying to make a Painter of him in that line' and by 1812 he is able to claim that his son has made much progress and now works 'at my side'. Apparently, he was also learning the art of etching, for, in this year, his father published for him his first engravings after his own small drawings, Mail Coach, Stage Coach, Barouche and Tandem.

The name of the artist and engraver does not appear on these prints, but a note on the drawing of Barouche in the British Museum states that these were James Pollard's earliest engravings. There seems little doubt that James was keen to learn all that his father could teach him, and the sporting prints that Robert Pollard published during this period, without artist's or engraver's names, may well have been the joint effort of father and son.

In 1813, there is a reference to James as a painter and, emphatically, not an engraver, but by 1816 there is a different story; James is concentrating on etching and finds it easier to make a living in this fashion rather than by painting, and for the next four years, in spite of his father's lack of enthusiasm, he seems to have had plenty of work 'making drawings, designs for engravers, and etching outlines to be aquatinted in imitation of Drawings'. 'It turns in the money quickest when employed by others'. Aquatinting, sometimes described as painting in acid (*aqua fortis*), had become, by the end of the eighteenth century, the most satisfactory medium for translating the sporting pictures of the period, the transparent quality of its

---

* Victoria and Albert Museum Library. Collection of 102 ALS 1774–1825 by Robert Pollard to Thomas Bewick. 86 J.24. Folder (L3258–1955).

tone effects giving a near imitation of a water-colour drawing. Most engravers of this type of work employed a mixture of etching and aquatint.

The outline of the subject was first etched on to a polished copper plate, which was then heated, and a solution of resin and spirits of wine was poured over it to form a ground. As the spirit evaporated it left behind a granulated surface made up of a multitude of minute particles of resin. When immersed in acid the plate was bitten around these tiny islands, and this caused the network effect which is a characteristic of aquatint. The required degrees of strength were obtained by repeated applications of acid, after 'stopping out' with varnish those parts of the plate upon which the acid was not to operate. When the plate was finished the parts deepest bitten held the most ink, and printed the darkest tones.

The final stages on the actual print were the work of the colourist who put in the colouring by hand, over the brown monochrome in which an aquatint was usually printed. The first crude washes were applied by assistants, and very often the remainder of the colouring as well, but sometimes the engraver, or artist himself, laid the more salient tones and delicate touches.

The first issue of each print was about two hundred pulls, and generally on Whatman paper: a paper of a fine strong quality, often with a date in the watermark. The plate would begin to deteriorate after about fifty impressions. Later issues were sometimes on Whatman paper, and sometimes on a smooth, thick paper, recognizable by the feel, but not always easy to distinguish under glass.

The rarity of fine engravings in good condition is due to a variety of causes. Prints were often given to children to be gummed into scrapbooks, or cut to pieces in order to make screens and fans; sometimes they were stretched on frames and varnished, with the title cut out and pasted on behind and, no doubt, fire took its toll. Although popular and sought after at the time of publication, they were not appreciated at their proper worth, and no one could have foretold the large sums for which many of them have since changed hands.

Coaching prints were published at popular prices, and an advertisement taken from the *Sporting Magazine* gives some idea of what was expected in a new issue: 'Price 7/6d. of a folio size, a highly finished coloured representation of a Mail Coach. It faithfully represents all the modern improvements in the vehicle, the most scrupulous attention having been paid to all the minutiae; it is seen travelling on the road with its usual velocity, the costume of the coachman, guard and passengers adding much to the pleasing effect produced, and is a most desirable embellishment to an apartment or portfolio'.

His father admits that James has been tolerably successful, and 'possesses both spirit and ability in the Department of the Arts he has made choice of. Horses in particular form the happiest proceeds of his pencil'.

In 1819 comes the first hint of the discord which eventually ended in the winding up of the family firm, R. Pollard and Sons, and Robert Pollard writes to Bewick that, although James's work in etching and aquatint possesses merit, 'he also knows it, and is rather too assuming of late tho' I hope, not to lead to parting—I cannot give up the mastery quite

yet for a year or two. He has some good qualities which I value, and in a late dispute I quoted to him, in the hearing of his brother William, the Fable of the Old Man and his Sons, intimating that our strength and consequences would be upheld when together, and the reverse on division or separation'.

By 1820, although the father admits that his two sons are working hard, there comes a depressing reference to lack of employment for the firm, and things seem to be coming to a standstill. But now occurred an event which was to alter the whole of James Pollard's future. Robert Pollard writes in February 1821 that the King's Printseller, Edward Orme, had commissioned James to paint a Mail Coach, Horses and Passengers on a signboard for an inn 'to be given by a Gent to a tenant who kept an inn on the Norwich road', and had then exhibited it in his shop window in Bond Street, where it was much admired. The Austrian Ambassador, Prince Esterhazy, taking a fancy to it, ordered that it be sent to the Embassy, and, on learning that it was not for sale, asked that another by the same artist be painted for him on a canvas. James obliged with the *Exeter Mail* (Cat. No. 2), and this was followed by orders for three more of the same subject from various sources (Cat. Nos. 3, 4 and 5). These paintings of fine quality, from the original design of the print, *Light Post Coach*, 1817, all measured 30 inches by 40 inches, and the artist made small variations in each of them, including at the patron's request, Piebald horses to the *Hastings Mail*. Robert Pollard commented, 'as the first was done very cheap the Prices are but poor pay, but we hope they will bring him into notice, and further orders'. The *York and Edinburgh Mail*, when auctioned in New York in 1967, fetched the record sale-room price for Pollard of $55,000.

So encouraged was James that he sent to the Academy his large painting of the *North Country Mails at the Peacock, Islington*, the original of the well-known engraving by T. Sutherland, and his father wrote, '. . . a bustling and busy scene. The figures of the outside Gentlemen and Ladies touched off with taste and spirit, and the Guards and Coachmen in New Scarlet coats make altogether a showy performance, size about 5 feet by 3½ . . . he had two applications to become purchasers; one a Gent of Fortune and of the "Four in Hand Club", that is a number of young gents who delight in driving their own horses and carriages, but chiefly those who are masters of the reins of 4 horses at once. He might, I believe, have had about 50 guineas for the Picture, but he stood out for more, and I did not like to interfere with it. He seemed very partial to it himself, and like a Father with his first child; he could not be tempted but, in some respects, it was as well as some additional ornaments have been added to the Mail Coaches since he finished his picture, which he means to alter to their present Taste and then try and reconcile himself to part with it as we all wish him to do, but yet leave it to his own discretion'.

When this picture was auctioned in 1960, it fetched the then record price for a painting by Pollard of £19,000. (Cat. No. 6).

Several letters follow in which Bewick is thanked for the advice he has given James about his drawing and particularly a 'hint about legs of horses at full speed' and the hope is expressed that the old man, 'always his well wisher', will be pleased to see the progress James is now making in his department of the Art of Painting.

In spite of this success, however, James still continued to work in aquatint for his father, engraving many of his own water colours and drawings of sporting subjects for publication by the family firm, and not until 1824, and then probably spurred on by matrimonial plans, did he exhibit again at the Academy, and also, for the first time, at the British Institution. His career as a painter now began to blossom. During the next few years he produced a variety of fine paintings of coaching scenes, and received commissions to paint the private carriages of various owners amongst the coaching fraternity, whilst many of the originals of his best known prints were also painted during this period.

In December 1825, at St. Mary's, Islington, James Pollard married Elizabeth Ridley, from the neighbouring village of St. Pancras, and seems to have decided then that the time had come to make the break with the family firm. His father's criticisms no doubt he found irksome, and the old man had ceased to be creative; his brother William, with whom he had worked so closely, died in 1826. James, with a wife to support and soon a family, wanted to be his own master. The break was a slow process, but no prints were published by R. Pollard and Sons after 1829. The premises at 11 Holloway Place, occupied since 1810 as a combined residence, studio and publishing house, were finally disposed of and James moved back to Islington Green.

He was a busy and successful man during the 1830s, and in 1839 appears to have begun a fruitful co-operation with J. F. Herring and Charles Hunt. Herring and Pollard together the previous year had already produced a large painting of the Doncaster Gold Cup; now, with Hunt as the engraver, three large prints were published, *The Grand Stand, Ascot*; *Doncaster Great St Leger*; and *An Extraordinary Trotting Match against Time*; in each case Pollard supplying the background and the crowd scenes (Cat. Nos. 236–239). This combination of talent might well have prospered, but in 1840 came misfortune. Pollard's wife and youngest daughter both died and it was a blow from which he took a long time to recover. It is said by his descendants that, for a time, he led an aimless and wandering existence and his remaining children were left to be brought up by their aunts. He did, however, after this interval, begin to paint again in 1842 but soon his touch became less sure, and his work slowly lost its magical quality. In addition lithography was now displacing aquatinting as a method of reproducing pictures and the services of sporting painters were no longer in great demand by the print publishers.

Times and fashions too were changing. Railways had arrived and *Omnibuses leaving the Nags Head* was a poor substitute for the great days of *The North Country Mails at the Peacock, Islington*.

Many were the omnibuses of local Islington proprietors he was forced to paint for his bread and butter, and on the back of one pencil sketch he revealed his discontent at the situation he found himself in, during the later eighteen-forties.

> To justice see Jack . . . bow,
> He's on no bed of roses now,
> And yet how strange the thing doth sound,
> For all that's done he gets a pound,

But such a pound as makes the knave,
Again a most unwilling slave.

He had wanted to work on his own and to leave the family firm, and had had, no doubt, some hard words with his father which may well have included the term 'knave'! But now that he was finding it difficult to earn a living, he was philosophical enough to admit he was getting his just deserts. Robert Pollard's views may well have been forceful for, without the business and, allied to it, James's talent, he had had no means of support for the last years of his life and had, in fact, to apply to the Artists' Benevolent Institution for assistance. James, with a wife and five children, had had his work cut out to support his own family.

From 1850 onwards, there is little to indicate the extent of his output. Occasionally, a painting appears with a date in these years, and, as late as 1859, a single fishing print after Pollard was published in the *Sporting Magazine*. Two small fishing paintings dated the same year clearly indicate the decline in quality, and these are the last works to be traced. It was in this year that he too received a small sum from the Artists Benevolent Institution.

For nearly all his life he had lived in various parts of Islington and Holloway, but in his last years, he moved to Chelsea to live with his son James Robert and family, first at Brompton, and later at 22 Robert Terrace, now Sydney Street, and it was here that he died on 15th October 1867, aged 75.

It was to his son that James Pollard left his drawings and paintings and, included among them, were several by Herring, his exact contemporary and always a close friend. Many remained in the possession of the family until the early years of the present century, but then the paintings were sold and the large tin trunk of drawings disposed of. Sir Walter Gilbey and Mr. Arthur du Cane, between them bought the several hundred drawings, and later with the aid of the National Art Collections Fund, the Du Cane collection of drawings was acquired for the British Museum.

Pollard's career divides easily into terms of decades. From 1810 until 1820, working with his father, he learnt to draw and to paint and, also, the art of engraving; the many prints that were published from his work during this period were after water colours and drawings. 1820 until 1830 were primarily the years of his finest Mail and Stage coach paintings. From 1830 to 1840, as well as coaching, came a large output of racing and steeplechasing paintings, many of which were engraved and published in sets. His best fishing paintings also belong to this period. From 1840 to 1850, a time of difficulty, he produced many small paintings of various subjects; coaches, omnibuses, and hunting scenes, and some of these were published as sets of lithographs. Some, indeed, were only potboilers. The total number of prints after Pollard's oils, water colours and drawings total about 343, and Pollard himself engraved about 146 of these. He also engraved 23 plates after other artists, and sometimes acted as colourist for the family firm, occasionally colouring in oil.

These figures can be regarded as reasonably accurate, but as regards his oil paintings, there can be no final answer. 408 are recorded in this catalogue.

If there is never complete agreement as to James Pollard's place as an artist, there can be no doubt that his work has unique charm. In some ways he seems to stand on his own. He was a fluent and perceptive draughtsman, with a fine sense of design, and most of his compositions are difficult to fault. There is, perhaps, a certain stiffness in some of his more studied and highly finished work, but when the spirit moved him, he could paint much more freely and become almost impressionistic in his technique.

In the past, he has at times been somewhat belittled, and the suggestion has been made that on occasion he raided Cooper Henderson. As Cooper Henderson was eleven years his junior, and Pollard's work had been accepted by the Academy whilst Henderson was still a boy at school, this is so much nonsense. In fact, Henderson did not start to earn his living as an artist until 1829, by which time Pollard was a man of nearly forty.

A similar study of his original paintings, compared with their engraver's interpretation of them, also makes nonsense of the suggestion that he was particularly fortunate in the work done for him by these craftsmen.

His rough sketches for coaching prints show that he was meticulously accurate in every technical detail of the coach itself, as well as with the topographical background, and his oil paintings are correct down to the smallest detail.

Perhaps one of the reasons why James Pollard has not always been properly appreciated, is that examples of his work are not easily seen. There are none exhibited in galleries in England, and those still in private collections are few and far between. The majority of his paintings have long since vanished to America. At the same time, the market has been flooded, both here and in the United States, with spurious paintings purporting to be by Pollard but, in reality, the work of a copyist called Sinclair.

Sinclair specialized many years ago in copying in oils, sporting and coaching prints, particularly those after Pollard, invariably making a few alterations of his own and sometimes amalgamating a coach from one print with a landscape from another. Although a fair artist in his own right, he seems to have known nothing of the technical details of the coaching system, and many of his pictures are given away by glaring mistakes. Sometimes mail coaches, legally restricted to not more than three passengers travelling 'outside', are seen in these paintings, breaking the law; and mail coaches painted a bright yellow or blue should be sufficient to betray his hand to anyone, unfamiliar with Pollard's genius, who has been taken in at first sight.

Copying paintings and prints is perfectly legitimate, but other nimble fingers have added handsome signatures such as a flourishing 'James Pollard' or 'James Pollard Pinxit'; Pollard himself never signed other than a simple 'J. Pollard', 'J.P.' or 'Pollard' often without a date and only on rare occasions adding Islington or Holloway. Quite often he omitted any form of signature. Even when nothing more than 'J. Pollard' has been attempted by the helping hand, its falsity is quickly detected by the lack of Pollard's characteristic twirl in the capital letters J and P.

It is only fair to the artist's reputation that these facts should be made known, even if it brings disappointment to possessors of these travesties of Pollard's art.

Of what manner of man James Pollard was it is possible, perhaps, to learn something from his pictures of everyday affairs, for his characters appear kindly and good natured and there is, in general, an atmosphere of Pickwickian good cheer.

His paintings indicate his versatility. Probably happiest when fishing on his favourite River Lea at Waltham Abbey, his fishing scenes, as befit a member of the 'Waltonians' show the genius of the artist allied to an angler's expert knowledge of his sport.

The expeditions to the Lea seem to have begun in 1831, a year when he also painted four coaching scenes at the local inn, 'The Falcon', one of them for the innkeeper, Mr. Heward, with whom he was on friendly terms (Cat. No. 77). A day with the gun did not come amiss (Cat. No. 353), and, if never a hunting man, in his younger days he was a keen follower of the Essex Hunt. All his life he was a great traveller about the countryside in pursuit of his occupation.

Obviously, his knowledge of stage-coach travelling was obtained at first hand, as witness an entry in the family diary for July 1836: 'James Pollard was thrown off a stage coach at Walham Green, on his way to Goodwood Races by the horses running away and over-turning the coach. Several of the passengers had their limbs broken, but J.P. escaped with a strained back.'

That he was a modest man there can be no doubt, since, as the following letter to the Royal Academy shows, he still felt it necessary, as late as 1839, to identify himself as the son of Robert Pollard.

Ap. 9 1839 10, Norfolk St.
Lower Road,
Islington.

Sir,
        Herewith I have sent two pictures for Exhibition, the subjects:
Maternal Care
and
Motherly Protection

Price Eighteen Pounds.

From your obedient servant
James Pollard

N.B. Son of the late Mr. Robt. Pollard of Holloway.

To H. Howard Esq., R.A.

These pictures, which were accepted for exhibition, were studies of a mare and foal, the pencil sketches for which are in the British Museum. Other pictures exhibited at the Academy were *North Country Mails at the Peacock, Islington*, in 1821 (Cat. No. 6) and two paintings in 1824 entitled *Incidents in Mail Coach Travelling* (Cat. Nos. 10 and 11).

The *Sporting Magazine*, perhaps over-critical, commented on these 'In the antique academy there are two paintings by Pollard of Mail Coaches—one going through water. The idea is clever, but the tails of the horses should drop close to the buttocks which is always the case

in going through water; some of the water should also have been represented as dropping from the wheels during their circumvolution.'

He also exhibited three pictures at the British Institute: *Coursers taking the Field at Hatfield Park*, in 1824 (Cat. No. 385); and in 1844, *Fox Hunting*, and *The Funeral of Tom Moody* (Cat. Nos. 300 and 301) and four drawings at the Royal Society of British Artists in Suffolk Street, in 1846.

Pollard can be likened to Henry Alken, who never exhibited; he was too busy during his best years, working for print publishers, to worry overmuch about exhibitions. It was only in his later years, when he was hoping for new patronage, that he decided to try again.
In his old age he was beloved by his numerous grandchildren, and known to many people as a benevolent, white-haired old gentleman, often to be seen attending Sunday service in St. Luke's Church, Chelsea, opposite the family home.

Let his epitaph on the family grave in Hornsey Churchyard speak for him:

> 'Beloved by his Family'.
> 'Now wasting years his former strength confound,
> and added woes have bowed him to the ground.
> Yet, by the stubble you may guess the grain,
> and mark the ruins of no vulgar man'.

Fortune had smiled on James Pollard in his middle years only to withdraw her favours later on as his capability declined and the age he had portrayed was submerged by the march of progress. Perhaps the particular charm of the coaching painting lies in its portrayal of this vanished world. Although hunting, shooting, and other field sports may have changed in detail, they are still carried on today much as they were at the time of Waterloo, forming a familiar part in the pattern of country life, but the great stage and mail coach system, the pride of Britain, disappeared forever with the coming of steam.

All the more valuable, therefore, are the impressions recorded by James Pollard, for, although many artists were to follow him with their 'Recollections' of this phase of English life, none could equal his experience at first hand.

# EXHIBITED WORKS

## ROYAL ACADEMY

1821 *North Country Mails at the Peacock, Islington.* 43in. by 60in. (see Cat. No. 6)

1824 *Incidents of Mail Coach Travelling.* (2), 20in. by 30in. (see Cat. Nos. 10 and 11)

1839 *Maternal Anxiety* and *Motherly Protection.* (2), (Studies of a Mare and Foal) (see Cat. Nos. 388 and 389)

## BRITISH INSTITUTION

1824 *Coursers taking the Field at Hatfield Park.* 40½in. by 56½in. (see Cat. No. 385)

1844 *Fox Hunting.* 16in. by 19in. (see Cat. No. 300)

1844 *The Funeral of Tom Moody.* 16½in. by 19in. (see Cat. No. 301)

## ROYAL SOCIETY OF BRITISH ARTISTS

*c.* 1846 Three Drawings

1846 A Drawing

# PLACES OF RESIDENCE

| | |
|---|---|
| 1792 | 15 Braynes Row, Spa Fields, Islington (birth place) |
| 1810–1826 | 11 Holloway Place, Holloway |
| 1832 | 18 Canonbury Street, Lower Road, Islington |
| 1834 | 3 Britannia Row, Lower Road, Islington |
| 1839 | 10 Norfolk Street, Lower Road, Islington |
| 1844 | 2 Milton Place, Islington Green |
| 1848 | 9 Prospect Place, Barnsbury, Islington |
| 1853 | Upper George's Place |
| 1859–1867 | In Brompton and, later, 22 Robert Terrace, Chelsea, the house of his son, James Robert Pollard |

# CATALOGUE

This catalogue has been compiled over a period of twenty years, and the majority of paintings listed have been seen or can be fully authenticated. Many additional paintings have appeared since the last catalogue was published in 1965 whilst others of doubtful attribution have been removed from the list. No doubt there are paintings in private collections which have not been recorded and further information would be welcome.

## Part 1 OIL PAINTINGS

## Part 2 ENGRAVED WORKS

# ABBREVIATIONS

*The following abbreviations are employed throughout the catalogue*

| ★★ | Indicating paintings illustrated |
|---|---|
| ★ | Indicating paintings illustrated in 1965 volume |
| *auct.* | Auction |
| b. | Born |
| B.I. | British Institution (1806–1867) |
| Christie's | Christie, Manson & Woods, Auctioneers, London |
| *coll.* | Collection of |
| d. | Died |
| *exhib.* | Exhibited |
| *lit.* | Literature |
| R.A. | Royal Academy, London (1769–    ) |
| *repr.* | Reproduced |
| S&D | Signed and dated |
| Sotheby's | Sotheby & Co., Auctioneers, London |
| Untraced | Refers to an engraved coaching painting which has never passed through the sale room, or appeared in a collection known to the author. The measurements given are of the engraving—an indication of the possible size of the original painting. |

# *Part 1*
# OIL PAINTINGS
★ Indicating paintings illustrated in 1965 volume
★★ Indicating paintings illustrated

## COACHING

### 1818

**1 ★SCHOOLING A PAIR**
A Drag leaving the Repository.
Canvas. 16½ × 12in. S&D J. Pollard 1818.
*exhib.* Ackermann's Galleries, London, 1963.
*coll.* N. C. Selway.
*In the possession of Mr. Paul Mellon, U.S.A.*

### 1820

**2★★THE EXETER ROYAL MAIL COACH**
The Mail on a Country Road.
Canvas. 30 × 40in. S&D J. Pollard 1820.
*exhib.* Ackermann's Galleries, London, 1963.
*coll.* Prince Esterhazy, 1820.
*coll.* Captain Adney.
*In the possession of Mr. N. C. Selway.*

### 1821

**3 ★THE YORK & EDINBURGH ROYAL MAIL COACH**
A variant of the Exeter Royal Mail Coach (No. 2).
Canvas. 30 × 40in. S&D J. Pollard 1821.
*coll.* J. Donahue, New York.
*auct.* Parke-Bernet, 3rd November 1967 (318).
Illustrated in sale catalogue.
*In the possession of Mr. J. Dick, Conn., U.S.A.*

**4★★THE HASTINGS ROYAL MAIL COACH**
A variant of the Exeter Royal Mail Coach, with
Piebald Horses (No. 2).
Canvas. 30 × 40in. Signed J. Pollard.
*auct.* Christie's, 1927. 27th May (19).
*coll.* Sampson.
Barron.
*auct.* Parke-Bernet. 20th October 1927 (84).
*coll.* Crowell, U.S.A.

**5★★THE BRISTOL ROYAL MAIL COACH**
A variant of the Exeter Royal Mail Coach (No. 2).
Canvas. 30 × 40in.
*coll.* Ellis and Smith.
*Now in U.S.A.*

**6 ★THE NORTH COUNTRY MAILS AT THE PEACOCK, ISLINGTON**
Canvas. 43 × 60¾in. S&D J. Pollard 1821.
*repr.* *Daily Telegraph*, 1st December 1960.
*Apollo* Magazine, April 1963.
Engraved by T. Sutherland.
*exhib.* R.A. 1821 (559).
Virginia Museum of Fine Arts, Richmond, U.S.A., 1963 (362).
R.A. 1964, 'Painting in England 1700–1850' The Paul Mellon Collection.
*auct.* Sotheby's, 30th November 1960 (175).
Illustrated in sale catalogue.
*coll.* H. Wormald.
Major W. F. Wormald.
*In the possession of Mr. Paul Mellon, U.S.A.*

### 1822

**7 ★A FOUR-IN-HAND IN HYDE PARK**
Canvas. 21 × 25in. S&D J.P. 1822.
*exhib.* Leggatt Brothers, London, 1959.
*coll.* Captain A. S. Wills.

**8 A STAGE COACH CLIMBING REIGATE HILL**
12 × 15in. (Size of engraving).
*repr.* Engraved by M. Dubourg.
*untraced.*

### 1823

**9 ★TANDEM**
A Stanhope on a Country Road.
Panel. 12 × 15in. Signed J. Pollard.
*repr.* Engraved by J. Gleadah.
*exhib.* Ackermann's Galleries, London, 1963.
*auct.* Sotheby's, 23rd January 1957.
*coll.* Lady Warrender.
N. C. Selway.
*In the possession of Mr. J. H. Crang, Toronto, Canada.*

### 1824

**INCIDENTS IN MAIL COACH TRAVELLING**
**10 THE RIVER IN FLOOD**
**11 SNOWED UP**
Canvas. 20 × 30in. (A Pair)
*exhib.* R.A. 1824, No. 773 and No. 774.
*coll.* A. S. Cochran.
*auct.* Christie's, 13th February 1920 (148).
*Now in U.S.A.*

12 ★THE FOUR-IN-HAND OF J. F. SHARP ESQUIRE
OUTSIDE THE ROEBUCK, TURNHAM GREEN
Canvas. 20 × 30in. S&D J. Pollard 1824.
*repr.* Engraved by M. Dubourg.
*exhib.* Virginia Museum of Fine Arts, Richmond,
U.S.A., 1963 (364).
*auct.* Christie's, 1939.
*coll.* F. Spicer.
D. North.
*In the possession of Mr. Paul Mellon, U.S.A.*

13 ★THE CARRIAGE & HORSES OF SMITH
BARRY ESQUIRE
Outside the Coach House.
Canvas. 32 × 48in. S&D J. Pollard 1824.
*repr.* *English Country Life, 1780–1830*, by E. Bovill,
1962.
*The Field*, 23rd May 1963.
*Country Life*, 23rd May 1963.
*exhib.* Ackermann's Galleries, London, 1963.
R.A., 1964, 'Painting in England 1700–1850'.
The Paul Mellon Collection.
*auct.* Sotheby's, 30th November 1960 (178), illus-
trated in sale catalogue.
*coll.* N. C. Selway.
*In the possession of Mr. Paul Mellon, U.S.A.*

1825
14★★THE MAIL COACH BY MOONLIGHT
The Bristol Mail in moonlit countryside.
Canvas. 20 × 30in. Signed J. Pollard.
*repr.* *A Book of Sporting Painters*, W. Shaw Sparrow,
1931.
*Daily Telegraph*, 23rd May 1963.
*exhib.* Ackermann's Galleries, London, 1963.
*auct.* Christie's, 1927.
*coll.* E. Leonard, New York.
*In the possession of Mr. N. C. Selway.*

15 ★THE MAIL COACH IN A FLOOD
Canvas. 20 × 30in. S&D J. Pollard 1825.
*auct.* Sotheby's, 23rd February 1938; Christie's, 17th
April 1964 (52), illustrated in catalogue.
*coll.* G. S. Martin.
A. Matti, Brazil.
*repr.* A variant engraved 1827 by F. Rosenberg.
*In the possession of Mr. N. C. Selway.*

16 ★THE MAIL COACH IN A DRIFT OF SNOW
Canvas. 20 × 30in. S&D J. Pollard 1825.
*auct.* Sotheby's, 23rd February 1938; Christie's, 17th
April 1964 (53).
*coll.* G. S. Martin.
A. Matti, Brazil.
*repr.* Engraved 1825 by R. G. Reeve.
*In the possession of Mr. N. C. Selway.*

17 THE MAIL COACH IN A STORM OF SNOW
Canvas. 20 × 30in.
*repr.* Engraved by R. G. Reeve.
*coll.* A. S. Cochran.
*auct.* Christie's, 13th February 1920 (148).

18 THE MAIL COACH IN A FOG
Canvas. 20 × 30in.
*coll.* A. S. Cochran.
*auct.* Christie's, 13th February 1920 (148).

19 THE MAIL COACH CHANGING HORSES
Outside the Old White Lion, Finchley.
Canvas. 20 × 30in.
*repr.* Engraved by R. G. Reeve.

20★★THE MAIL COACH ON HIS MAJESTY'S
BIRTHDAY
With Hammer-cloth, Rosettes, and Nosegays.
Canvas. 20 × 30in.
*auct.* Sotheby's, 18th June 1969 (134), illustrated in
catalogue.
*coll.* J. Angus.
*In the possession of Mr. N. C. Selway.*

21 ★THE LEEDS MAIL PASSING A COUNTRY
HOUSE AND PARK
Canvas. 20 × 30in.
*repr.* *The Sphere*, 1953.
*exhib.* Ackermann's Galleries, London, 1963.
*auct.* Christie's, July 1955.
*coll.* Brigadier-General A. F. Ferguson.
N. C. Selway.
*In the possession of Mr. J. Dick, Conn., U.S.A.*

22★★THE NORWICH MAIL ON A COUNTRY
ROAD
With a large Mansion on a hill beyond.
Canvas. 20 × 30in. (a variant of No. 21).
*coll.* N. C. Selway.
*auct.* Christie's, 16th July 1965 (41), illustrated in
catalogue.
Sotheby's, 12th July 1967 (147), illustrated in
catalogue.
*exhib.* National Art Museum of Sport, New York,
1970.

1826
23 ★THE MAIL COACH IN A THUNDERSTORM
ON NEWMARKET HEATH
Canvas. 20 × 30in. S&D J. Pollard 1826.
*coll.* Sir Abe Bailey.
*repr.* A variant engraved 1827 by R. G. Reeve.
*In the National Gallery of South Africa, Cape Town.*

24 ★THE ELEPHANT AND CASTLE ON THE
BRIGHTON ROAD
Canvas. 22 × 31in. S&D J. Pollard 1826.
*repr.* Engraved by T. Fielding.
*exhib.* Ackermann's Galleries, London, 1963.
Victoria and Albert Museum, Growth of
London Exhibition, 1964.
*coll.* H. Cushing, New York.
C. Dunlap, New York.
N. C. Selway.
*In the possession of Mr. J. Dick, Conn., U.S.A.*

25 ★THE BIRMINGHAM TALLY-HO! COACHES
PASSING THE CROWN AT HOLLOWAY
Canvas. 20 × 30in. S&D J. Pollard 1826.
*repr.* Engraved by C. Bentley. See also Cat. No. 39.
*Country Life,* 23rd May 1963.
*exhib.* Frank Partridge, London, 1960.
Ackermann's Galleries, London, 1963.
*coll.* R. Boardman, Boston, U.S.A.
*In the possession of Mr. N. C. Selway.*

26 ★THE ARRIVAL OF THE MAIL BY POST
CHAISE AT YORK POST OFFICE
Canvas. 20 × 30in. S&D J. Pollard 1826.
*repr.* Apollo, November 1960.
*Country Life; The Field,* 23rd May 1963.
*exhib.* Frank Partridge, London, 1960.
Ackermann's Galleries, London, 1963.
*auct.* Christie's, 22nd January 1960 (67).
*coll.* N. C. Selway.
*In the possession of Mr. E. A. Berger.*

27 A STANHOPE WITH A FAVOURITE HORSE
Canvas. 11 × 16in. The property of Mr. Angell.
*repr.* Engraved by T. Fielding.

28 A VIEW IN THE REGENT'S PARK
Canvas. 11 × 16in.
*repr.* Engraved by W. Callow.

29 A MORNING DRIVE TO THE GARDENS OF
THE ZOOLOGICAL SOCIETY
Canvas. 11 × 16in.
*repr.* Engraved by W. Callow.

30★★THE LIONESS ATTACKING THE HORSE OF
THE EXETER MAIL COACH
Canvas. 20 × 30in. S&D J. Pollard 1826.
*repr.* Subject engraved by R. Havell, from a water
colour by Pollard, 1817.
*In the possession of Mr. N. C. Selway.*

1827

31★★THE SOUTHAMPTON MAIL AT THE OLD
GENERAL POST OFFICE
Canvas. 14 × 17in.
*auct.* Anderson Galleries, New York, 28th March
1935 (12).
*coll.* E. P. Wanamaker.
*In the possession of Mrs. Rayner, New York.*

32 ★THE ROYAL MAILS LEAVING THE ANGEL,
ISLINGTON
Canvas. 40 × 57in. S&D J. Pollard 1827.
*auct.* Christie's, 26th July 1902 (38).
*coll.* Sir Walter Gilbey.
*auct.* Christie's, 12th March 1910 (125).
*coll.* C. Agnew.

33 ★THE MAIL COACH IN A FLOOD
Panel. 12 × 16in. Signed J. Pollard.
*repr.* The Field, 23rd May 1963.
Engraved by F. Rosenberg.
*exhib.* Ackermann's Galleries, London, 1963.
*auct.* Sotheby's, 15th July 1964 (153).
*coll.* N. C. Selway.
*In the possession of Mr. J. Dick, Conn., U.S.A.*

34 THE MAIL COACH IN A DRIFT OF SNOW
Canvas. 13 × 18in. S&D J. Pollard 1827. (Pair to
No. 35.)
*repr.* A variant engraved by R. G. Reeve, 1825.
*auct.* Sotheby's, 15th July 1964 (152). Illustrated in
catalogue.
*coll.* N. C. Selway.
*In the possession of Mr. J. Dick, Conn., U.S.A.*

35 ★THE MAIL COACH DESCENDING A HILL IN
A SNOW STORM
Canvas. 13 × 18in. (Pair to No. 34.)
*coll.* N. C. Selway.
*In the possession of Mr. J. Dick, Conn., U.S.A.*

36 STAGE COACH TRAVELLING
A Stage Coach and a Mail passing on a steep hill.
11 × 16in. (Size of engraving).
*repr.* Engraved by R. Rosenberg.
*untraced.*

1828
37 ★WEST COUNTRY MAILS AT THE
GLOUCESTER COFFEE HOUSE, PICCADILLY
Canvas. 20½ × 30½in. S&D J. Pollard 1828.
*repr.* Engraved by C. Rosenberg.
*In the possession of The Links Club, New York.*

38 ★THE ROYAL MAILS AT THE ANGEL INN, ISLINGTON, ON THE NIGHT OF HIS MAJESTY'S BIRTHDAY
Canvas. 20 × 30in. Signed J. Pollard.
*repr.* Engraved by R. G. Reeve.
*coll.* Ambrose Clark, Long Island, New York.
*exhib.* Richard Green, London, 1969.
*In the possession of Mr. N. C. Selway.*

39★★THE BIRMINGHAM TALLY-HO! COACHES PASSING THE CROWN AT HOLLOWAY
Canvas. 17½ × 23½in.
*repr.* Original painting from which the engraving by C. Bentley was made. See also Cat. No. 25.
*auct.* Christie's, 18th March 1913.
Sotheby's, 15th July 1964 (163).
*coll.* A. S. Cochran, New York, U.S.A.
A. C. Bostwick, Long Island, N.Y., U.S.A.
*In the possession of Mr. J. H. Crang, Toronto, Canada.*

40 HYDE PARK CORNER
The Classic Screen with several types of private carriages.
16½ × 24in. (Size of engraving.)
*repr.* Engraved by R. and C. Rosenberg.
*auct.* A copy appeared in a New York Sale in 1956.
*untraced.*

41 ★A STAGE COACH PASSING BALBY, YORKS.
The 'Chesterfield Champion' with a full load.
Canvas. 12 × 17in. S&D J. Pollard 1828.
*exhib.* Ackermann's Galleries, London, 1963.
*auct.* Christie's, 7th December 1934 (66).
*coll.* Colonel Birkin.
N. Harrison Kay.
N. C. Selway.
*In the possession of Mr. R. Graham.*

42 ★THE ROYAL MAILS LEAVING THE GENERAL POST OFFICE
Canvas. 14 × 17in. S&D J. Pollard 1828.
*exhib.* Ackermann's Galleries, London, 1963.
*auct.* Parke-Bernet Galleries, New York, 4th March 1952 (286).
*coll.* Palmer, New York.
*In the possession of Mr. N. C. Selway.*

43 ★CAPTAIN COPLAND DRIVING 'TAM-O-SHANTER' IN THE REGENT'S PARK
Canvas. 16½ × 20½in. S&D J. Pollard 1828.
*coll.* E. J. Rousuck, New York.
*auct.* Christie's, 17th November 1947.

44 ★PETER BROWN AND HIS WIFE DRIVING TOM THUMB
Canvas. 15 × 20in. S&D J. Pollard, Holloway, 1828.
*In the Sterling and Francine Clark Art Institute, Williamstown, Mass., U.S.A.*

45 THE PROCESSION OF H.M. GEORGE IV TO ASCOT HEATH RACES
Canvas. 9½ × 37in.
*repr.* Engraved by R. G. Reeve.
*auct.* Christie's, 11th June 1915 (364).
*coll.* Sir Walter Gilbey.

46 MAIL COACH
A Royal Mail passing a gun with two dogs.
Canvas. 8½ × 13in. (Pair to No. 47.)
*repr.* Engraved by F. Rosenberg.
*untraced.*

47★★STAGE COACH
'The Wonder' passing a country house.
Canvas. 8½ × 13in. (Pair to No. 46.) S&D J. Pollard 1828.
*repr.* Engraved by F. Rosenberg.
*coll.* Prestige.
*auct.* Sotheby's, 3rd April 1968 (74).
Illustrated in sale catalogue.
*In the possession of Mr. J. Dick, Conn., U.S.A.*

48★★THE BIRMINGHAM ECLIPSE AT THE ANGEL, ISLINGTON
Canvas. 12½ × 17½in. Signed J. Pollard.
*exhib.* Ackermann's Galleries, London, 1963.
*coll.* Lord Norrie.
N. C. Selway.
*In the possession of Mr. J. Dick., Conn., U.S.A.*

49★★THE ROYAL BRUCE PASSING THE BALD-FACED STAG, FINCHLEY
Canvas. 13½ × 19½in.
*coll.* D. Watterson.
*In the possession of Mr. J. H. Crang, Toronto, Canada.*

1829
50 ★THE ROYAL MAILS' DEPARTURE FROM THE GENERAL POST OFFICE
Canvas. 17 × 24in.
*repr.* Engraved by R. G. Reeve.
*In the possession of Mr. H. Frelinghuysen, Far Hills, N.J., U.S.A.*

51★★THE ROYAL MAILS STARTING FROM THE GENERAL POST OFFICE AT NIGHT
Canvas. 16 × 25in.
*repr.* Engraved by R. G. Reeve.
*In the possession of Mr. C. Thieriot, New York, U.S.A.*

52 THE NEW GENERAL POST OFFICE 1829
The Departure of the Mails on a summer's evening.
13¾ × 25⅜in. (Size of engraving.)
*repr.* Engraved by J. Pollard.
*untraced.*

53 ★THE ROYAL MAILS ARRIVING AT THE
GENERAL POST OFFICE AT DAWN
Canvas. 10 × 23in. Signed J. Pollard.
*exhib.* Ackermann's Galleries, London, 1963.
*coll.* N. C. Selway.
*In the possession of Mr. J. H. Crang, Toronto, Canada.*

54 ★MAIL COACH BY MOONLIGHT
Passing a Toll Gate.
Canvas. 20 × 30in. Signed J. Pollard. (Pair to No. 55.)
*repr.* Engraved by G. Hunt.
*coll.* G. D. Widener.
*In the possession of Mrs.Wetherill, Pennsylvania, U.S.A.*

55 ★MAIL COACH IN A FOG
Canvas. 20 × 30in. (Pair to No. 54.)
*repr.* Engraved by G. Hunt.
*coll.* G. D. Widener.
*In the possession of Mrs. Wetherill, Pennsylvania, U.S.A.*

56★★THE BIRMINGHAM ECLIPSE AT THE BALD-
FACED STAG, FINCHLEY
Canvas. 14 × 18in. S&D J. Pollard 1829.
*In the possession of Mr. P. Frelinghuysen, Washington,
D.C., U.S.A.*

57 WARWICK AND BIRMINGHAM COACH:
THE 'OLD BIRMINGHAM' COACH
Canvas. 14 × 17in.
*repr.* Engraved by G. Hunt (attributed to).
*coll.* H. Foster, New York, U.S.A.

Undated before 1830
58 MR. FRENCH'S CARRIAGE IN REGENT'S
PARK
Original drawing in Print Room, British Museum.

59★★MR. SHARP'S TANDEM WITH POPPET AND
PEACOCK
Canvas. 12 × 18in.
*coll.* T. A. Hall, Burnley.
*auct.* Sotheby's, 17th June 1970 (86). Illustrated in
sale catalogue.

1830
60★★THE NORWICH MAIL AT THE COACH
AND HORSES, ILFORD
Canvas. 14 × 17½in. S&D J. Pollard 1830.
*coll.* Mrs. Van Praag, New York.
*auct.* Sotheby's, 18th June 1969 (140). Illustrated in
sale catalogue.
*In the possession of Mr. N. C. Selway.*

61 ★THE NORWICH MAIL AT THE COACH
AND HORSES, ILFORD
Canvas. 14 × 17½in. S&D J. Pollard 1830.
*coll.* Sir Abe Bailey.
*In the National Gallery of South Africa, Cape Town.*

62 ★THE WEST COUNTRY MAILS LEAVING THE
INN YARD OF THE SWAN WITH TWO NECKS
Canvas. 16½ × 23½in. S&D J. Pollard 1830.
*repr.* Engraved by F. Rosenberg.
*auct.* Christie's, 1930.
*coll.* Lord Revelstoke.
Earl of Kenmare.
*In the possession of Mr. P. Freylinghuysen, Washington,
D.C., U.S.A.*

63★★THE GUILDFORD COACH PASSING A
CHURCH AND AN INN
Canvas. 16 × 20½in. S&D J. Pollard 1830.
*In the possession of Mr. J. Dick, Conn., U.S.A.*

64 ★THE HULL MAIL AT THE SWAN, ENFIELD
Canvas. 13½ × 17½in. S&D J. Pollard 1830.
*auct.* Christie's, 1927.
*coll.* Barron.
*In the possession of Mr. J. M. Schiff, New York, U.S.A.*

65★★BAROUCHE
A Barouche drawn by four greys passing a Jacobean
mansion.
Canvas. 16½ × 21in. S&D J. Pollard 1830.
*auct.* Sotheby's, 12th March 1969 (169). Illustrated in
sale catalogue.
*coll.* M. A. Finch.
*In the possession of Mr. J. Dick, Conn., U.S.A.*

66★★MAIL BEHIND TIME
The Royal Mail passing the Bald-Faced Stag, Finchley.
Canvas. 14 × 17in. Signed J. Pollard.
*repr.* Engraved by R. G. Reeve.
*auct.* Anderson Galleries, N.Y., 28th March 1935 (12).
*coll.* E. P. Wanamaker.
*In the possession of Mrs. Rayner, New York.*

67**APPROACH TO CHRISTMAS
The Norwich 'Times' in the Mile End Road.
Canvas. 14 × 21in. Signed J. Pollard.
*repr.* Engraved by G. Hunt.
*coll.* Duke of Hamilton.
*auct.* Christie's, 23rd May 1919.
*coll.* H. J. Chisholm, U.S.A.
*auct.* Christie's, 17th June 1966 (81). Illustrated in sale
catalogue.
*In the possession of Mr. J. Dick, Conn., U.S.A.*

68 A MAIL IN DEEP SNOW
Canvas. 15 × 20in. (Size of engraving).
*repr.* Engraved by G. Hunt.
*untraced.*

69 A VIEW ON THE HIGHGATE ROAD
The Birmingham Tally-Ho! passing 'The Woodman'.
Canvas. 16 × 20in.(Pair to No.71.)(Size of engraving).
*repr.* Engraved by G. Hunt.
*untraced.*

70**HIGHGATE TUNNEL
A Mail coach entering London through the Northern
Gateway.
Canvas. 17 × 21in. (Pair to No. 70).
*repr.* Engraved by G. Hunt.
*exhib.* Ackermann's Galleries, London, 1963.
*coll.* N. C. Selway.
*auct.* Sotheby's, 12th November 1969 (68).
Illustrated in catalogue.
*In the possession of Mrs. M. R. Hodson.*

1831
71**THE ROYAL BRUCE AT THE ANGEL INN
Canvas. 13½ × 17in. S&D J. Pollard 1831.
*auct.* Christie's, 1927.
*coll.* Barron.
*In the possession of Mr. J. M. Schiff, New York, U.S.A.*

72**LIVERPOOL, BIRMINGHAM, WARWICK
AND LONDON COACH AT THE PEACOCK,
ISLINGTON
Canvas. 14 × 17in.
*In the possession of Mr. J. Dick, Conn., U.S.A.*

73 *DOVER MAIL
The coach on a country road.
Canvas. 10½ × 14½ in.
*coll.* Sir Abe Bailey.
*In the National Gallery of South Africa, Cape Town.*

74**THE LIVERPOOL UMPIRE
A crowded coach on a country road.
Canvas. 13½ × 16½in. S&D J. Pollard 1831.
*repr.* Engraved by G. Hunt.
*exhib.* Ackermann's Galleries, London, 1963.
*auct.* Sotheby's, 14th November 1962 (165).
*coll.* N. C. Selway.
*In the possession of Mr. J. Dick, Conn., U.S.A.*

75 *THE MAIL AT KINGSLAND GATE AT NIGHT
Canvas. 14 × 17½in. S&D J. Pollard 1831.
*auct.* Christie's, 1931.
*coll.* S. E. Kennedy.
Sir M. Singer.
*In the possession of Mr. P. Moore, Convent, N.J., U.S.A.*

76 *THE CAMBRIDGE MAIL AT THE FALCON,
WALTHAM CROSS ON MAY DAY
Canvas. 20 × 30in. S&D J. Pollard 1831.
*coll.* E. J. Heward.
*auct.* Christie's, 8th May 1936.
*In the possession of The Marquess of Bute.*

77**A TRAVELLING CARRIAGE CHANGING
HORSES AT THE FALCON, WALTHAM CROSS
Canvas. 14 × 18in.
*auct.* Christie's, 25th April 1969 (70). Illustrated in
sale catalogue.

78 *THE HULL MAIL AT THE FALCON,
WALTHAM CROSS
Canvas. 14¼ × 17¾in. S&D J. Pollard 1831.
*repr.* Engraved by R. G. Reeve.
*auct.* Christie's, 1927.
*coll.* Barron.
Mrs. Cutting.
*auct.* New York, June 1964.

79**THE HULL MAIL AT THE FALCON,
WALTHAM CROSS
Canvas. 13½ × 17½in. S&D J. Pollard 1831.
*coll.* S. E. Kennedy.
Sir M. Singer.

80**THE CAMBRIDGE TELEGRAPH AT THE
WHITE HORSE, FETTER LANE
Canvas. 16 × 21in. Signed J. Pollard.
*repr.* Engraved by G. Hunt.
*coll.* H. J. Chisholm, New York.
*auct.* Christie's, 17th June 1966 (82). Illustrated in
sale catalogue.

81**THE SHEFFIELD MAIL ON A COUNTRY ROAD
Canvas. 9½ × 12in. S&D J. Pollard 1831.
*auct.* Christie's, 6th November 1964 (2).
*In the possession of Mr. J. Dick, Conn., U.S.A.*

82 ★THE YARMOUTH MAIL AT THE THREE
CUPS, COLCHESTER
Canvas. 14 × 17in. S&D J. Pollard 1831.
*exhib.* Ackermann's Galleries, London, 1963.
*coll.* Miss E. Marx.
N. C. Selway.
*In the possession of Mr. J. Dick, Conn., U.S.A.*

1832
83 ★A NORTH-EAST VIEW OF THE NEW
GENERAL POST OFFICE
Canvas. 15 × 23in. S&D J. Pollard 1832.
*repr.* Engraved by H. C. Pyall.
*In the possession of Mr. H. Freylinghuysen, Far Hills,
N.J., U.S.A.*

84 THE COACH AND HORSES, ILFORD
The Mail changing Horses.
12 × 17in. (Pair to No. 86) (Size of engraving.)
*repr.* Engraved by R. G. Reeve.
*untraced.*

85 ★THE EAGLE, SNARESBROOK
The Norwich Mail entering Epping Forest.
Panel. 12 × 17in. Signed J. Pollard. (Pair to No. 85.)
*repr.* Engraved by R. G. Reeve.
*The Field,* 23rd May 1963.
*exhib.* Ackermann's Galleries, London, 1963.
*coll.* Lady Ffennell.
N. C. Selway.
*In the possession of Mr. S. Clarke, Virginia, U.S.A.*

1833
86 ★A GIG PASSING THE EAGLE, SNARESBROOK
Canvas. 17 × 21in. S&D J. Pollard, Islington, 1833.
*In the possession of Mrs. Good.*

1834
87 QUICKSILVER ROYAL MAIL
The Mail passing Kew Bridge and the 'Star and Garter'.
Canvas. 14 × 17½in. S&D J. Pollard 1834.
*repr.* Engraved by C. Hunt.
*auct.* Sotheby's, 16th December 1927.
*coll.* F. Ward.
*In the possession of Mr. H. Frelinghuysen, Far Hills,
N.J., U.S.A.*

1835
88★★QUICKSILVER ROYAL MAIL
The Mail passing Kew Bridge and the 'Star and Garter'.
Canvas. 13½ × 17in. S&D J. Pollard 1835.
*repr.* Engraved by C. Hunt.
*coll.* A. S. Cochran, New York, U.S.A.
*In the possession of Mrs. Ewing, New York, U.S.A.*

89 ★QUICKSILVER ROYAL MAIL
The Mail passing Kew Bridge and the 'Star and Garter'.
Canvas. 14 × 17½in. Signed J. Pollard.
*In the possession of Mr. G. Donald, Ontario, Canada.*

90★★PEVERIL OF THE PEAK
The Derby, Leicester and Manchester Coach at the
Peacock, Islington
Canvas. 13¾ × 17½in. S&D J. Pollard 1835.
*exhib.* Virginia Museum of Fine Arts, Richmond,
U.S.A., 1963.
*In the possession of Mr. Paul Mellon, U.S.A.*

91 ★THE FARINGDON COACH PASSING
BUCKLAND HOUSE
Canvas. 20 × 28in. S&D J. Pollard, Islington, 1835.
*exhib.* Ackermann's Galleries, London, 1963.
*coll.* D. North.
N. C. Selway.
*In the possession of Mr. Paul Mellon, U.S.A.*

92★★H.M. WILLIAM IV DRIVING IN WINDSOR
PARK
Canvas. 15 × 27in. S&D J. Pollard 1835.
*coll.* Ambrose Clark, Long Island, N.Y., U.S.A.
*In the possession of Mr. P. Kerr, New York, U.S.A.*

93 CAMBRIDGE COACH
Canvas. 14 × 17in. (Size of engraving.)
*repr.* Engraved.
*untraced.*

94 MANCHESTER COACH
A Stage coach descending a steep hill.
Canvas. 14 × 17in.
*repr.* Engraved.
*auct.* Christie's, 23rd July 1900 (98).

95 A FOUR-IN-HAND PASSING A RACECOURSE
14 × 17in. (Size of engraving.)
*repr.* Engraved.
*untraced.* Probable size 10 × 14in.

96★★TRAVELLING CARRIAGE
Panel. 9¾ × 13½in.
*repr.* Engraved.
*coll.* W. Capel-Kirby.
*auct.* Sotheby's, 18th November 1970 (86). Illustrated
in sale catalogue.

97**THE RED ROVER BRIGHTON COACH
Panel. 9¾ × 13½in.
coll.  W. Capel-Kirby.
auct.  Sotheby's, 18th November 1970 (85). Illustrated
       in sale catalogue.

98 *EDINBURGH EXPRESS
The coach passing a country house.
Panel. 8 × 14in.
repr.  Engraved.
coll.  Sir W. R. Younger, Bart, Edinburgh.
auct.  Sotheby's, 17th June 1970 (96). Illustrated in
       sale catalogue.

99 LIVERPOOL, DERBY, MANCHESTER AND
   LONDON COACH
Canvas. 14 × 17in.
repr.  Engraved.
auct.  Christie's, 17th November 1900 (159).

1836

100**PEVERIL OF THE PEAK
The Derby, Leicester and Manchester Coach at the
Peacock, Islington
Canvas. 13¾ × 17½in. S&D J. Pollard 1836.
coll.  M. D. Truesdale, New York.
exhib. Richard Green, London, 1970.

101 *WHITE HORSE CELLAR, PICCADILLY—
    HATCHETTS
Stage Coaches about to depart.
Canvas. 20 × 28in. S&D J. Pollard 1836.
auct.  Christie's, 14th May 1951.
coll.  Hutchinson Gallery of Sporting Paintings,
       London (now dispersed).

102**WHITE HORSE CELLAR, PICCADILLY—
    HATCHETTS
The Devonport Mail and a Barouche in foreground.
Canvas. 17½ × 25½in.
auct.  Christie's, 18th November 1966 (13).
In the possession of Mr. J. Dick, Conn., U.S.A.

103 *MANCHESTER AND LIVERPOOL COACH
    PASSING WHITTINGTON COLLEGE,
    HIGHGATE
Canvas. 14½ × 18in. S&D J. Pollard 1836.
repr.  'The English Carriage' 1948. Hugh
       McCausland.
exhib. Metropolitan Museum of Art, New York,
       1937.
auct.  Christie's, 1914.
coll.  Ambrose Clark, Long Island, New York.

104 *ARRIVAL OF THE LONDON AND CLAPHAM
    COACH OUTSIDE THE WINDMILL INN,
    CLAPHAM COMMON
Canvas. 30 × 47in. S&D J. Pollard 1836.
auct.  Christie's, 1913.
coll.  A. Baird-Carter.
       A. S. Cochran, New York, U.S.A.
In the possession of Mr. Charles H. Thieriot, Long Island,
    New York, U.S.A.

105 THE SNOW STORM—DELAY OF THE MAIL
11 × 16in. (Size of engraving.)
repr.  Engraved by R. G. Reeve and by Himeley.
untraced.

1837
SCENES DURING THE GREAT SNOW
STORM DECEMBER 1836 (Set of four)
Canvas. 10 × 13in. each.
repr.  Lithographed by G. B. Campion.

106 THE DEVONPORT MAIL ASSISTED BY SIX
    FRESH POST-HORSES
untraced.

107**THE LIVERPOOL MAIL IN A SNOW STORM
    NEAR ST. ALBANS
auct.  Christie's, 6th November 1964. (1).
In the possession of Mr. J. Dick, Conn., U.S.A.

108 THE BIRMINGHAM MAIL FAST IN THE
    SNOW
untraced.

109 THE LOUTH MAIL STOPPED BY THE SNOW
untraced.

110 *THE TAGLIONI WINDSOR COACH
The coach and a team of piebalds passing Cranford
Park.
Canvas. 11 × 16in. S&D J. Pollard 1837.
repr.  Engraved by R. G. Reeve.
exhib. Ackermann's Galleries, London, 1963.
coll.  T. Brackenbury.
       T. Brown, Cambridge.
       N. C. Selway.
In the possession of Mr. R. Graham.

1838
111**THE FOUR-IN-HAND CLUB, HYDE PARK
Driving past the Magazine.
Canvas. 14 × 22in.
repr.  Engraved by J. Harris.
coll.  Major G. L. Wickham.
In the possession of the Royal Horse Guards, entitled
    'Driving Club and Blues'.

112**HOLLOWAY AND BANK OMNIBUS
'SOVEREIGN'
Canvas. 15 × 21in. Signed 'Pollard' on coach.
*auct.*  Parke-Bernet Galleries, New York, U.S.A.
26th April 1956 (306). Illustrated in catalogue.
*coll.*  Loew, New York, U.S.A.

113**TRAFALGAR SQUARE
Canvas. 21 × 31in.
*coll.*  H. J. Chisholm, U.S.A.
*auct.*  Christie's, 17th June 1966 (80). Illustrated in
catalogue.
*In the possession of Mr. J. Dick, Conn., U.S.A.*

114**KIDD'S OMNIBUS TO TURNHAM GREEN
AT THE ANGEL INN
Canvas. 20 × 24in. Signed J. Pollard.
*coll.*  S. F. Hammon, U.S.A.

SCENES ON THE ROAD, OR A TRIP TO
EPSOM AND BACK (Set of four)
Canvas. Each 12 × 20in.
*repr.*  Engraved by J. Harris.
115**HYDE PARK CORNER
Signed 'Pollard' 1838.
*coll.*  C. Dunlap, New York, U.S.A.
*In the possession of Mr. J. R. Dick, Conn., U.S.A.*

116**THE LORD NELSON INN AT CHEAM
S&D J. Pollard 1838.
*coll.*  C. Dunlap, New York, U.S.A.
*In the possession of Mr. J. R. Dick, Conn., U.S.A.*

117**THE COCK AT SUTTON
Signed 'Pollard' on barouche.
*coll.*  C. Dunlap, New York, U.S.A.
*In the possession of Mr. J. R. Dick, Conn., U.S.A.*

118  KENNINGTON GATE
*This painting is said to have been destroyed by fire.*

1840
119**A DOG CART WITH DRIVER AND
PASSENGER
Canvas. 17 × 21in. S&D J. Pollard 1840.
*auct.*  Parke-Bernet Galleries, New York, U.S.A.
26th April 1956 (309). Illustrated in catalogue.
*coll.*  Loew, New York, U.S.A.
J. Donahue, New York.
*auct.*  Parke-Bernet, 3rd November 1967 (317).
*In the possession of Mr. J. Dick, Conn., U.S.A.*

1842
120**GOING TO THE DERBY
The Spread Eagle, Epsom.
Canvas.

1843
121  *SPRINGING THEM TO MEET THE TRAIN
Panel. 6 × 9in. S&D J. Pollard 1843. (Pair to No. 122.)
*exhib.*  Ackermann's Galleries, London, 1963.
*coll.*  N. C. Selway.
*In the possession of Mr. John W. Warner, Washington,
D.C., U.S.A.*

122  *JUST IN TIME FOR THE HULL MAIL
Panel. 6 × 9in. Signed J. Pollard. (Pair to No. 121.)
*exhib.*  Ackermann's Galleries, London, 1963.
*coll.*  N. C. Selway.
*In the possession of Mr. John W. Warner, Washington,
D.C., U.S.A.*

123  A COACH RACING THE TRAIN
Panel. 8½ × 11½in. (Pair to No. 124.)
*In the possession of Mr. J. Dick, Conn., U.S.A.*

124  FULL CRY
Panel 8½ × 11½in. S&D. J. Pollard 1843. (Pair to
No. 123.)
*In the possession of Mr. J. Dick, Conn., U.S.A.*

1844
125  *THE FAVORITE OMNIBUS IN A SNOW
SCENE
Canvas. S&D J. Pollard 1844. (Pair to No. 126.)

126  *THE FAVORITE OMNIBUS IN A COUNTRY
LANDSCAPE
Canvas. S&D J. Pollard 1844. (Pair to No. 125.)

1845
127  *LAST JOURNEY OF THE LOUTH MAIL,
9th December 1845
Canvas. 9 × 12in.
*auct.*  Christie's, 10th December 1971 (114). Illus-
trated in sale catalogue.

128  E. & J. WILSON'S OMNIBUS
Showing his visitor the way to Chelsea: St. Patrick's
Day, 17th March 1845.
Canvas. 12 × 16in. S &D J. Pollard 1845.
*In The London Museum.*

129  THE CHEAPSIDE OMNIBUS AT A HALT
Canvas. 10½ × 14in. S&D J. Pollard 1845.
*auct.*  Sotheby's, March 1964.

31

## 1846

**129A MAIL COACHES PASSING AT NIGHT**
Canvas. 9 × 13½in. S&D J. Pollard 1846.
*auct.* Christie's, 12th November 1971 (177).

**130 ★OUTSIDE THE WHITE LION**
A Mail arriving with passengers for the Meet. A lame horse being led is seen on the left.
Canvas. 9¾ × 13½in. (Pair to No. 131.)

**131 ★LEADERS BREAKING AWAY AFTER HOUNDS**
Canvas. 9¾ × 13½in. S&D J. Pollard 1846. (Pair to No. 130.)

**132 THE LOUTH MAIL—LAST RUN**
9th DECEMBER 1845
Canvas. 17 × 27in. S&D J. Pollard 1846.
*exhib.* Ackermann's Galleries, London.
*In the possession of Mr. J. Dick, Conn., U.S.A.*

**133– COACHING SCENES WITH HUNT IN**
**134 PROGRESS IN BACKGROUND (A Pair).**
Canvas. 10 × 14in. S&D J. Pollard 1846.
*In the possession of Lord Fairhaven.*

**135 THE HALFWAY HOUSE: A MAIL COACH OUTSIDE THE GREYHOUND INN**
Canvas. 9¼ × 13½in. S&D J. Pollard 1846.
*auct.* Sotheby's, 7th July 1965 (147).
*In the possession of Mr. J. Dick, Conn., U.S.A.*

**136 THE FAVORITE OMNIBUS: TO AND FROM BLACKWALL TUNNEL**
Canvas. 10½ × 14½in. S&D. J. Pollard 1846.
*auct.* Christie's, 2nd April 1965 (71).
*In the possesion of Mr. J. Warner, Washington, D.C., U.S.A.*

**137★★THE LOUTH MAIL SETTING DOWN A PASSENGER**
Canvas. 10 × 14in. S&D J. Pollard 1846.
*coll.* P. Rolo.
*auct.* Sotheby's, 19th November 1969 (69). Illustrated in sale catalogue.

## 1847

**137A THE FAVORITE OMNIBUS AT THE HANLEY ARMS**
Canvas. 10 × 13½in. S&D. J. Pollard 1847.
*auct.* Christie's, 10th December 1971 (115). Illustrated in sale catalogue.

**138★★THE LAST MAIL LEAVING NEWCASTLE—**
5th JULY 1847
Panel. 9 × 12in. S&D J. Pollard 1847.
*coll.* G. Weston.
*auct.* Christie's, 3rd May 1968 (84). Illustrated in sale catalogue.

## 1848

**139 ★THE LAST MAIL LEAVING NEWCASTLE—**
5th JULY 1847
Canvas. 16¾ × 26in. S&D J. Pollard 1848.
*repr.* *Country Life,* 11th May 1961.
*exhib.* Post Office Exhibition, 1890.
Virginia Museum of Fine Arts, Richmond, U.S.A., 1963.
*auct.* Sotheby's, 19th April 1961 (172). Illustrated in catalogue.
*coll.* Edward Macnamara (for whom it was painted by the Artist).
Mrs. Brandon.
*In the possession of Mr. Paul Mellon, U.S.A.*

**140★★ROYAL DAY MAIL IN A SNOWY LANDSCAPE**
Canvas. 13 × 17in. Signed J. Pollard.
*exhib.* Post Office Exhibition, 1890.
*auct.* Sotheby's, 19th April 1961 (167).
*coll.* Edward Macnamara.
Mrs. Brandon.

**141★★ROYAL DAY MAIL IN SUMMER PASSING ISLINGTON GREEN**
Canvas. 13 × 17in. S&D J. Pollard 1848.
*exhib.* Post Office Exhibition, 1890.
*auct.* Sotheby's, 19th April 1961 (168).
*coll.* Edward Macnamara.
Mrs. Brandon.

**142★★THE WOODFORD COACH AT THE EAGLE SNARESBROOK**
Canvas. 13 × 17in. S&D J. Pollard 1848.
*exhib.* Post Office Exhibition, 1890.
*auct.* Sotheby's, 19th April 1961 (169).
*coll.* Edward Macnamara.
Mrs. Brandon.

**143 MR. MACNAMARA'S GIG, OUTSIDE HIS YARD, CASTLE ST. E.C.**
Canvas. 16¼ × 20½in.
*exhib.* Post Office Exhibition, 1890.
*auct.* Sotheby's, 19th April 1961 (166). Illustrated in catalogue.
Sotheby's, 10th March 1965 (165).
*coll.* Edward Macnamara.
Mrs. Frances Brandon.
*In the possession of Mr. J. Dick, Conn., U.S.A.*

144 A MAIL CART ON THE LONDON ROAD
Board. 9 × 12¾in.
*exhib.* Post Office Exhibition, 1890.
*auct.* Sotheby's, 19th April 1961 (171).
*coll.* Edward Macnamara.
Mrs. Brandon.

145 THE ROYAL DAY MAIL AT SNARESBROOK
Canvas. 13 × 17in. S&D J. Pollard 1848.
*exhib.* Post Office Exhibition, 1890.
Ackermann's Galleries, London, 1963.
*auct.* Sotheby's, 19th April 1961 (170).
Christie's, 2nd April 1965 (81).
*coll.* Edward Macnamara.
Mrs. Brandon.
N. C. Selway.
*In the possession of Mr. J. Dick, Conn., U.S.A.*

146 ★KENDALL'S BUS PASSING ISLINGTON
GREEN
Canvas. 17 × 21in. S&D J. Pollard 1848.
*repr.* Apollo, September 1964.
*exhib.* Ackermann's Galleries, London, 1963.
Harrogate Antique Dealers Fair, 1964.
*auct.* Sotheby's, 15th July 1964 (155).
*coll.* N. C. Selway.
*In the possession of Mr. J. Dick, Conn., U.S.A.*

147★★THE HULL MAIL WITH FOX AND HOUNDS
IN FULL CRY
Panel. 8½ × 12in. (Pair to No. 148).
*In the possession of Mr. D. A. C. Hutchinson.*

148 THE HADLEY BARNET AND FINCHLEY
ROYAL DAY MAIL
Panel. 8½ × 12in. Signed J. Pollard. (Pair to No. 147).
*In the possession of Mr. D. A. C. Hutchinson.*

1849
149★★FLACK'S CAMBRIDGE COACH AT STAM-
FORD HILL GATE
Canvas. 13 × 17in. S&D J. Pollard 1849.
*exhib.* Leggatt Brothers 1959.
*auct.* Sotheby's, 1959.
*coll.* Mrs. F. L. Flack.
*In the possession of Mr. J. Story Smith, Pennsylvania,
U.S.A.*

1850
150 AN OMNIBUS PASSING THE THREE
COMPASSES
Canvas. 14 × 18in. S&D J. Pollard 1850.
*In the London Museum.*

1853
151 AN OMNIBUS
Canvas. 8 × 10in.
*coll.* C. Sessler, Philadelphia, Pa., U.S.A.

1856
152 THE PEACOCK INN WITH OMNIBUSES
SETTING OFF
Canvas. 27 × 35in. S&D J. Pollard 1856.

Undated after 1840
153 THE LOUTH MAIL IN SNOW
Canvas. 12 × 16in.
*coll.* G. Weston.
*auct.* Christie's, 3rd May 1968 (85).
Illustrated in sale catalogue.
Christie's, 25th April 1969 (90).

154 ISLINGTON TO OXFORD STREET
OMNIBUS
Canvas. 14 × 18in.
*auct.* Parke-Bernet Galleries, New York, U.S.A.
26th April 1956 (467).
*coll.* Loew, New York.

155 THE HULL MAIL LEAVING AN INN
Panel. 7 × 9½in.
*coll.* J. Donahue, New York.
*auct.* Parke-Bernet, 3rd November 1967 (320).

156 FRENCH'S OMNIBUS
Canvas. 9 × 14in. Signed J. Pollard.

157 THE ROYAL MAIL PASSING A FARM ON
FIRE
Panel. 8 × 10in.
*auct.* Sotheby's, 14th March 1962 (172).

158 MORNING—A MAIL COACH STOP AT
DAWN
Panel. 9 × 12½in.

159 ★OMNIBUSES LEAVING THE NAG'S HEAD,
HOLLOWAY
Canvas. 17½ × 23½in.
*auct.* Christie's, 18th January 1946.

160 A RUNAWAY MAIL
Canvas. 10 × 12in. Signed J. Pollard.
*auct.* Sotheby's, 19th April 1961 (144).

COACHING SCENES
(A Series). Panel c. 9 × 12in.
*repr.* Lithographed by E. Hull and Dean.

161 THE SLEEPY GATEKEEPER
Signed J. Pollard.
*auct.* Sotheby's, 14th March 1962.

162 GOOD MORNING

163 GOOD NIGHT

164 JUST IN TIME

165 MUSIC HATH CHARMS TO AN OLD
HUNTER

166 HOLD HARD

167 WHEEL ON FIRE. SPRINGING THEM UP
TO MEET THE TRAIN

168 COACHING—SUMMER
7½ × 10in. (Pair to No. 169).
*In the possession of Mr. E. A. Berger.*

169 COACHING—WINTER
7½ × 10in. (Pair to No. 168.)
*In the possession of Mr. E. A. Berger.*

170 OMNIBUSES AT THE NAG'S HEAD
Proprietor Mr. Palmer.
Canvas. 18 × 24in. Signed JP.
*coll.* M. Wheeler.
*auct.* Sotheby's, 13th July 1966 (113).
*In the possession of Mrs. M. R. Hodson.*

171 BEHIND TIME. NO ROOM SIR! THE
PLACE IS BOOKED
Original drawing in Print Room, British Museum.

172 *A STANHOPE GIG PASSING A FARM
Canvas. 18¼ × 22½in.
*coll.* E. J. Rousuck, New York.

173 LONDON PARCELS DELIVERY
Canvas. 10 × 14in.
*auct.* Christie's.

174 ROYAL DAY MAIL—BARNET, HADLEY
FINCHLEY
Canvas. 8 × 10in. Signed J. Pollard.

175 THE TALLY-HO! AT BARNET
Panel. 8 × 10in. (Pair to No. 176).

176 THE DERBY COACH PICKING UP A
PASSENGER
Panel. 8 × 10in. (Pair to No. 175).

RACING

### 1826

180 EPSOM RACES FOR THE GREAT DERBY
STAKES
Canvas. 13 × 25in.
*repr.* Engraved by J. Pollard.

### 1828

181** 'THE COLONEL'
Winner of the St. Leger 1828. W. Scott up.
S&D J. Pollard 1828.
*repr.* Engraved by J. Pollard.
*In the possession of Mr. J. Dick, Conn., U.S.A.*

182 *THE RACE FOR THE DERBY STAKES 1828
The Duke of Rutland's 'Cadland' beating Mr. Petre's
'The Colonel'.
Canvas. 13 × 17in. S&D J. Pollard 1828.
*repr.* Engraved by R. G. Reeve.
*auct.* Sotheby's, 14th November 1962 (177). Illustrated in catalogue.
*coll.* The Earl of Bradford.
*In the possession of Mr. J. Dick, Conn., U.S.A.*

### 1829

183 THE RACE FOR THE GOLD CUP AT ASCOT
Canvas. 14 × 18in.
*repr.* Engraved by J. Edge.

184 THE RACE FOR THE DERBY STAKES AT
EPSOM 1829
Canvas. 14 × 18in.
*repr.* Engraved by J. Gleadah.

### 1831

185 MR. G. OSBALDESTON RIDING HIS HORSE
AGAINST TIME AT NEWMARKET
Canvas. 13 × 17½in.
*repr.* Engraved by J. Pollard.

186 *DONCASTER RACES
Horses starting for the St. Leger.
Canvas. 14¼ × 25in. S&D J. Pollard 1831.
*repr.* Engraved by Smart and Hunt.
*coll.* R. Younger.
*In the possession of Mr. Paul Mellon, U.S.A.*

### 1833

187 *DONCASTER RACES
Passing the Judge's Stand.
Canvas. 14¼ × 25in.
*repr.* Engraved by Smart and Hunt.
*coll.* R. Younger.
*In the possession of Mr. Paul Mellon, U.S.A.*

188**EPSOM RACES
Race for the Derby Stakes.
Canvas. 14 × 25in.
*repr.* Engraved by H. Pyall.
*coll.* Singer.
*In the possession of Mrs. M. E. Tippetts, Virginia, U.S.A.*

189**GOODWOOD RACES
Canvas. 14 × 25 in.
*repr.* Engraved by H. Pyall.
*coll.* Singer.
*In the possession of Mrs. M. E. Tippetts, Virginia, U.S.A.*

### 1834

190 ASCOT RACES
'Glaucus' beating 'Rockingham' and 'Samarkand'.
Canvas. 14 × 25in.
*repr.* Engraved by H. Pyall.

EPSOM RACES (A Pair)
Canvas. Each 14 × 24in.
*repr.* Engraved by Smart and Hunt.

191**NOW THEY'RE OFF
Start for the Derby Stakes.
*exhib.* Jenkins' Art Gallery, Toronto, 1925 (17).
*In the possession of Mr. C. H. Thieriot, Long Island, N.Y., U.S.A.*

192 HERE THEY COME
Passing Tattenham Corner.

A PROSPECTIVE VIEW OF EPSOM RACES
(set of six)
Canvas. Each 11¾ × 18⅝in.
*repr.* Engraved by C. Hunt 1836.

193**SADDLING IN THE WARREN
S&D J. Pollard 1834.
*coll.* Gifford A. Cochran.
*auct.* Parke-Bernet, 12th November 1931 (21).
*In the possession of Mr. Charles H. Thieriot, Long Island, U.S.A.*

194**THE BETTING POST
S&D J. Pollard 1834.
*coll.* G. A. Cochran.
*In the possession of Mr. J. Dick, Conn., U.S.A.*

### 1835

195**PREPARING TO START
S&D J. Pollard 1835.
*coll.* G. A. Cochran.
*In the possession of Mr. J. Dick, Conn., U.S.A.*

196 THE GRAND STAND

197**THE RACE OVER
S&D J. Pollard 1835.
*coll.* G. A. Cochran.
*In the possession of Mr. J. Dick, Conn., U.S.A.*

198**SETTLING DAY AT TATTERSALL'S
*coll.* G. A. Cochran.
*In the possession of Mr. J. Dick, Conn., U.S.A.*

199 A VIEW OF THE GRANDSTAND, DONCASTER
With portraits of the St. Leger Winners 1815–1834.
Canvas. 14 × 24in.
*repr.* Engraved by H. Pyall.

### 1836

RACE FOR THE GREAT ST. LEGER STAKES
1836 (set of four)
Canvas. Each 15 × 25in.
*repr.* Engraved by J. Harris.

200**THE FALSE START

201 OFF IN GOOD STYLE

202**WHO IS THE WINNER?

203 ALL OVER BUT SETTLING

204 'BAY MIDDLETON'
Winner of the Derby 1836.
Canvas. 8 × 10¼in. Signed J. Pollard.
*In the possession of Mr. R. A. McAlpine.*

BRITISH HORSE RACING (A set of four)
Canvas. Each 10½ × 14½in.
*repr.* Engraved by R. G. Reeve.

205 GOODWOOD GRAND STAND
Preparing to start.

206 DONCASTER GRAND STAND
Race for the Gold Cup.

207 ASCOT GRAND STAND
Coming in.

208 EPSOM GRAND STAND
Winner of the Derby Race.

### 1837

209**THE KING'S PLATE, GOODWOOD
'Slane' beating 'Zohrab'.
Canvas. 14 × 17½in. S&D J. Pollard 1837.
*auct.* Parke-Bernet Galleries, New York, U.S.A., 17th November 1956 (32), 24th November 1939 (18).
*coll.* S. Flint.
*In the possession of Mr. T. W. Bullitt, Louisville, U.S.A.*

210 THE RACE BETWEEN 'FOIG OF BALLAGH' AND 'THE EMPEROR'
Canvas. S&D J. Pollard 1837.

### 1839
211**THE DERBY 1839
'Bloomsbury' winning in a snowstorm.
Canvas. 14 × 17½in.

212 *RUN OFF OF THE ST. LEGER 1839
After the Dead Heat between 'Charles XII' and 'Euclid'.
Canvas 12½ × 17½in. The date 1825 after the signature on this painting is false.
The original drawing in the Print Room, British Museum is marked 'Engraved'.

### 1840
213 'LAUNCELOT'
W. Scott up. Winner of the St. Leger.
Canvas. 12½ × 17½in.
S&D J. Pollard 1840.

### 1842
THE DERBY PETS (Set of four)
Canvas. Each 12 × 17½in.
*repr.* Engraved by J. Pollard.

214 SALE OF THE COLT

215 THE TRIAL

216 THE ARRIVAL

217 THE WINNER
*In the possession of Mr. Paul Mellon, U.S.A. (216 & 217)*

### 1843
218**'COTHERSTONE'
Winner of the Derby 1843.
Canvas. 13½ × 17⅛in. S&D J. Pollard 1843.
*exhib.* Richard Green Gallery, 1970.

219 MR. BOWES HORSE 'COTHERSTONE' WINNING THE DERBY 1843
13 × 13in.
*repr.* Lithographed by Dean.

220 THE DESPERATE RACE FOR THE ST. LEGER 1843
13 × 13in.
*repr.* Lithographed by Dean.

### 1845
221 THE RACE FOR THE PLATE, THE GIFT OF H.M. THE EMPEROR OF RUSSIA 1845
13 × 13in.
*repr.* Lithographed by Dean.

222 'THE MERRY MONARCH'
The Property of Mr. Gratwick. Winner of the Derby 1845.
9¾ × 13½in.
*repr.* Lithographed by Dean.

### 1846
223 THE FIRST TIME OF SADDLING IN FRONT OF THE GRAND STAND EPSOM 1846
13 × 13in.
*repr.* Lithographed by Dean.

224 DISMOUNTING IN THE ENCLOSURE AT ASCOT 1846
13 × 13in.
*repr.* Lithographed by Dean.

225 'ALARM'
The Property of Mr. Greville. Winner of the Emperor's Plate, Ascot 1846.
9¾ × 13½in.
*repr.* Lithographed by Dean.

### 1851
226 'FLYING DUTCHMAN'
Winner of the Derby 1849.
Canvas. 8 × 10in. Signed J. Pollard 1851.
*In the possession of Mr. Speer Ogle.*

227 'VOLTIGEUR'
Winner of the Derby 1850.
Canvas. 6 × 9in.

228 'TEDDINGTON'
Winner of the Derby 1851.
Original drawing in the Print Room, British Museum.

229 THE ANNUAL PROCESSION OF QUEEN VICTORIA ON ASCOT RACE COURSE

230 MR. ANDERSON'S MARE 'THE HARE'
Winner of the Waltham Abbey Stakes.
Canvas.

231 'FLYING CHILDERS' (1715–1741)

A groom of the earlier period holds 'Flying Childers' whilst they are admired by a horse and jockey of Pollard's era.

Original drawing in Print Room, British Museum.

232 A TURN OUT FROM THE CAVALRY BARRACKS, WINDSOR, FOR ASCOT RACES

Original drawing in Print Room, British Museum.

## IN COLLABORATION WITH
## J. F. HERRING

### 1839

236 DONCASTER GOLD CUP 1838

This picture was painted by James Pollard and the horses painted in by J. F. Herring.
Canvas. 44 × 81in. Signed J. F. Herring 1839.
*repr.* Apollo Magazine, 1960.
*exhib.* Frank Partridge, London, 1960.
*In the possession of Mr. H. J. Joel.*

237 GRANDSTAND, ASCOT 1839

Grandstand and crowd painted by Pollard, and figures and horses in foreground by J. F. Herring.
Panel. 20 × 30in. Signed J. F. Herring.
*exhib.* Ackermann's Galleries, London, 1965.
*repr.* Engraved by C. Hunt.
*coll.* Whitney, New York, U.S.A.
*In the possession of Mrs. H. L. Middleton.*

238 DONCASTER GREAT ST. LEGER 1839

Grandstand and crowd painted by Pollard.
19 × 29in.
*repr.* Engraved by C. Hunt.
Illustrated Nevill, 'Old English Sporting Prints'.

239 TROTTING: 'GUSTAVUS' AND 'TOMMY'

Mr. Alexander Burke Trotting on Sunbury Common 1839. The spectators and background by Pollard.
Panel. 20 × 29½in. Signed J. F. Herring.
*coll.* W. Woodward, Baltimore Museum (attributed to J. F. Herring).
*repr.* Engraved by C. Hunt, entitled: 'Extraordinary Trotting Match against Time'.

## STEEPLECHASING

### 1832

ST. ALBANS GRAND STEEPLECHASE
(Set of six)
Canvas. 12 × 17in. each.
*coll.* Duke of Hamilton.
*In the possession of National Trust of Scotland, Brodick Castle.*

240★★ THE TURF HOTEL AT ST. ALBANS
*repr.* Engraved by G. & C. Hunt.

241 FIRST LEAP
*repr.* Engraved by H. Pyall.

242 TURNING AN ANGLE
*repr.* Engraved by C. Bentley.

243 STRUGGLE AT THE BANK
*repr.* Engraved by H. Pyall.

244 WITHIN VIEW
*repr.* Engraved by G. & C. Hunt.

245★★ THE WINNING POST
S&D 1832.
*repr.* Engraved by G. & C. Hunt.

### 1833

246– NORTHAMPTON GRAND STEEPLECHASE
251 (Set of six).
Canvas. 12½ × 17in. each.
*repr.* Engraved by H. Pyall.
*coll.* (One) Major G. Paget.

### 1834

★ ST. ALBANS TALLY-HO STAKES (A pair)
Canvas. 12 × 17in. each.
*repr.* Engraved by G. and C. Hunt.

252 FIRST LEAP

253 SECOND LEAP
*auct.* Sotheby's, 15th July 1964 (No. 162). Illustrated in catalogue.
*coll.* Duke of Hamilton.
A. C. Bostwick, Long Island, U.S.A.
*In the possession of Mrs. J. Pethick.*

### 1835

254 ★ CAPTAIN BECHER ON 'VIVIAN' WINNING THE OXFORDSHIRE GRAND STEEPLECHASE
Canvas. 12½ × 17½in.
Original drawing in Print Room, British Museum, marked 'Engraved'.

## 1836

255– AYLESBURY GRAND STEEPLECHASE
258  The Light Weight Stake. (Set of four)
Canvas. 14 × 20in. each.
Engraved by J. Harris.

## 1837

259– ST. ALBANS STEEPLECHASE (Set of four)
262  Canvas. 14 × 19in. each.
*repr.*  One engraved by R. G. Reeve and three by
C. Hunt.

CHANCES OF THE STEEPLECHASE (Set of
eight: two 1839)
Canvas. 13¾ × 19in. each (1–6).
*repr.*  Engraved by Rosenberg and C. G. & Hunt.

263  CAPT. W. BECHER AND 'VIVIAN'
Aylesbury to wit.
Engraved by C. Rosenberg.

264  MR. SEFFERT AND 'MOONRAKER'
At St. Albans.
Engraved by C. Hunt.

265  MR. POWELL AND 'SALADIN' AT
AYLESBURY
Engraved by C. Rosenberg.

266  MR. COOPER AND 'THE PONY' AT
AYLESBURY 1836
Engraved by C. Rosenberg.

267  MR. SEFFERT AND 'GRIMALDI'
Engraved by C. Hunt.

268  MR. RICE AND 'RED DEER'
Engraved by G. Hunt.

## 1838

269– ST. ALBANS GRAND STEEPLECHASE (Set of
272  four)
Canvas. 12½ × 17in. each.
*repr.*  Engraved.

## 1839

CHANCES OF THE STEEPLECHASE (Set of
eight: six 1837)
Canvas. 13½ × 18½in. each (7 and 8).
*repr.*  Engraved (no engraver's name).

273  MR. J. MASON AND 'LOTTERY'
Winning at Liverpool.
Engraved.

274  MR. MARTIN AND 'PAULINA'
At Liverpool.
Engraved.

275  'LOTTERY': WINNER OF THE FIRST
GRAND NATIONAL 1839
Canvas.
*repr.*  *Connoisseur*, April 1941.
*coll.*  Maj.-Gen. Sir J. Hanbury-Williams

## 1840

INCIDENTS OF THE STEEPLECHASE (A pair)

276** LIVERPOOL, APRIL 5, 1840

277** CHELTENHAM, 1840
Canvas. 12½ × 17in.
*coll.*  Ambrose Clark, Long Island, New York,
U.S.A.
*repr.*  Engraved by T. Helme.

## Undated

278  STEEPLECHASING
A rider clearing a fence.
Canvas. 13½ × 17½in.
*repr.*  *Art News*, June 1926.

## HUNTING

## 1820

280** EDWARD BROCKMAN, M.P. FOR HYTHE
IN HUNTING GREEN AT COVERTSIDE
(with hounds and two other members of the East
Kent Hunt).
Canvas. 22 × 26¾in. S&D J. Pollard 1820.
*coll.*  Sir E. Mountain., Bt.

## Undated after 1820

281  *KING GEORGE III HUNTING IN WINDSOR
FOREST
Canvas. 30 × 42in. Signed J. Pollard.
*repr.*  Engraved by M. Dubourg.
*lit.*  *British Sporting Artists* by W. Shaw Sparrow,
page 16.
*In the possession of Mr. Harry T. Peters, Jr., New York,
U.S.A.*

282  *KING GEORGE III RETURNING FROM
HUNTING
Canvas. 30 × 42in. Signed J. Pollard.
*repr.*  Engraved by M. Dubourg.
*In the possession of Mr. Harry T. Peters, Jr., New York,
U.S.A.*
Pair painted some time after the publication in 1820
of the engravings of the same subject.

1829

283– TOM MOODY—THE WHIPPER IN
286 (Set of four)
Canvas. 9¾ × 10¾in.
*repr.* Engraved by G. Hunt.

★★THE FUNERAL
S&D J. Pollard 1829.
*In the possession of the Marquess of Bute. (One).*

287 POSTBOYS WATERING THEIR HORSES
Canvas. 14 × 17½in. (Pair to No. 288.)
*repr.* Engraved by H. Pyall.

288 HUNTERS ON THEIR WAY TO THE
STABLES
Canvas. 14 × 17½in. (Pair to No. 287.)
*repr.* Engraved by H. Pyall.

1830

289 FOX GOING TO COVER
(Pair to No. 290.)
Canvas. 10½ × 13⅜in. Signed J. Pollard.
*coll.* Walter Stone.
*In the possession of the Walker Art Gallery, Liverpool.*

290 FOX LEAVING COVER
(Pair to No. 289).
Canvas. 10½ × 13⅜in. S &D J. Pollard 1830.
*In the possession of the Walker Art Gallery, Liverpool.*

1831

291 ★A HUNTING SCENE
Canvas. 17 × 23in. S&D J. Pollard 1831.
*coll.* C. W. Englehard.

1839

FOX HUNTING (Set of four)
Canvas. 16 × 21¾in. S&D J. Pollard 1839.

292★★FOX HUNTER'S MEETING OUTSIDE AN INN

293★★BREAKING COVER

294★★FOX CHASE (S&D)

295★★THE DEATH
*repr.* Engraved by C. Hunt.
*auct.* Sotheby's, 18th March 1970 (117). Illustrated
in sale catalogue.

1840

296– THE JOLLY OLD SQUIRE (Set of four)
299 Canvas. 14⅞ × 20⅝in. each.
*repr.* Engraved by H. Papprill.

1844

300 FOX HUNTING
Canvas. 16 × 19in.
*exhib.* B.I. 1844.

301 THE FUNERAL OF TOM MOODY
Canvas. 16 × 19in.
*exhib.* B.I. 1844.

1846

302– HUNTING SCENES (four)
305 Canvas & Panel. 10 × 14in. each.
(One signed J. Pollard 1846).
*auct.* Bonham's, London, 1964.
*In the possession of Mr. J. Warner, Washington, D.C.,
U.S.A.*

1849

FOX HUNTING (Set of four)
Canvas. 10 × 14in.

306 PUSH HIM AT IT SIR!

307 GALLANTLY DONE SIR!

308 ONE THAT CAN GO THE PACE

309 GOING IN AND OUT CLEVERLY
*repr.* Lithographed by C. Dennis.
*auct.* Bonhams, London, 1964.
*In the possession of Mr. J. Warner, Washington, D.C.
U.S.A.*

310 A HUNTER IN A STABLE WITH GROOM,
AND A YOUNG MAN IN HUNTING PINK
Canvas. 12 × 16in. S&D J. Pollard 1849.
*coll.* M. Spink.

311 A CHIP OFF THE OLD BLOCK
A child at the Meet on a pony.
10 × 14in.
*repr.* Lithographed by Sutcliffe.
*auct.* Bonhams, London, 1964.
*In the possession of Mr. J. Warner, Washington, D.C.,
U.S.A.*

1850

312 STABLE SCENE

313 OUTSIDE AN INN
(A pair)
Canvas. 12 × 16in. S&D J. Pollard 1850.
*coll.* Simon Carter.

### 1853

**314  A STABLE SCENE**
Canvas. 9 × 12in. S&D J. Pollard 1853.
*coll.*   Wessex Gallery, Odiham.

### Undated after 1840

**315  TALLY-HO**
Canvas. 8½ × 12in. Pair to No. 316.

**316  THE KILL**
Canvas. 8½ × 12in. Pair to No. 315.

**317  *FULL CRY**
Canvas. 10 × 14in.
*exhib.* Ackermann's Galleries, London, 1959.
Illustrated in catalogue.

**318  THE INVALID AT THE SMITHY**

**319  THE CONVALESCENT IN THE FIELD**
(A pair).
A Hunter wears a protective collar.
Canvas.

**FOX HUNTING** (Set of four)
10 × 14in.)
Drawings in the British Museum.

**320  THE MEET**

**321  THE CHECK**

**322  THE DEATH**

**323  REFUGE FOR THE DESTITUTE**
Engraved.

**324  *A HUNTING SCENE**
Canvas. 9¾ × 13¾in.
*In the possession of Mr. E. A. Berger.*

**HUNTING SCENES**
Canvas. Each 9⅝ × 13¾in.

**325  *IN FULL CRY**

**326  *FINDING THE SCENT**

**327  THE CHAPLAIN OF THE CHASE**
Original sketch illustrated in the *Connoisseur, 1922,*
and is in the British Museum.
The story of a country parson hunting with George
III.

**328  A HUNTING PHAETON—A PARTY GOING
TO COVER**
Canvas. 12½ × 17½in.
*repr.*   Engraved by C. Hunt.

**329  FULL CRY**
(A variant of No. 317).

**330  GONE AWAY**
(A pair).
Canvas. 9¾ × 14in.
*In the possession of Mrs. Hitt, New York, U.S.A.*

**331  A FOX HUNT IN A FARMYARD**
Canvas. 17 × 21in.
*coll.*   James Pollard.
*In the possession of Mr. F. Jacobs (Great-grandson of
the artist).*

**332  BREAKFAST BEFORE THE HUNT**
Canvas. 10¼ × 14in. (Pair to No. 333.)
*coll.*   Lady Fairhaven.
*In the possession of Lord Fairhaven.*

**333  RIDING ON WITH HOUNDS**
Canvas. 10¼ × 14in. (Pair to No. 332.)
*coll.*   Lady Fairhaven.
*In the possession of Lord Fairhaven.*

**334–  TOM MOODY**
**335**  (A pair).
10 × 14in.
*repr.*   Lithographed by H. Heath.

**336–  IN FULL CRY**
**337  CLOSING IN**
(A pair).
10 × 14in.
*coll.*   P. Moore, Convent, New Jersey, U.S.A.

**338  A HUNTING SCENE**
Clearing a fence.
Millboard. 9 × 12in.

**339  IN FULL CRY**
The Jolly Old Squire.
Millboard. 9 × 12½in.
*coll.*   Miss Frick, New York, U.S.A.

340 HORN AND THE WHISTLE

341 HORN AND THE CHASE

342 MORNING
9 × 12in.
*In the U.S.A.*

## SHOOTING

### 1828

345 ANTICIPATION

346 POSSESSION (A pair)
Canvas. 8¼ × 11in.
*repr.* Engraved by H. Pyall.

### 1830

SHOOTING
Set of four.
Canvas. 13 × 17in.
*repr.* Engraved.

347 PHEASANT

348 GROUSE

349 PARTRIDGE

350 WOODCOCK

### 1832

351 *DUCK SHOOTING
Canvas. 9½ × 13½in. S&D J.P. 1832.
*auct.* Christie's, 22nd May 1959.
*coll.* Colonel K. E. Savill.

### 1838

352 *DUCK SHOOTING
Canvas. 14½ × 18in. S&D J. Pollard 1838.
*coll.* E. J. Rousuck, New York.
*In the possession of Mr. Charles H. Thieriot, Long Island, U.S.A.*

### 1846

353 **JAMES POLLARD AND HIS SON JAMES ROBERT 'COUNTING THE BAG'
On board. 9 × 11½in. S &D J. Pollard 1846.
*coll.* K. M. Watts.
*auct.* Sotheby's, 17th March 1971 (102).
*In the possession of Mr. N. C. Selway.*

### Undated

354 *GROUSE SHOOTING
Two guns with their dogs on the Moors.
Canvas. 12 × 14in. Signed J.P.

355 **PARTRIDGE SHOOTING
Canvas. 10 × 14in.
*coll.* Walter Stone.
*exhib.* Whitechapel 1950. English Sporting Pictures.
*In the possession of the Walker Art Gallery, Liverpool.*

## FISHING

### 1831

356 *FLY FISHING AT TOTTENHAM MILLS
(Pair to No. 357.)
The Ferry Boat Inn.
Canvas. 13¼ × 16¾in. S&D J. Pollard 1831.
*repr.* Engraved by G. Hunt and P. Himely.
*exhib.* Viscount Allendale's Loan Exhibition of Sporting Pictures 1931, London.
*auct.* Christie's, 25th April 1940 (110). A. N. Gilbey sale.
*lit.* *Animal Painters* by Sir W. Gilbey.
*coll.* A. N. Gilbey.
C. Dunlap, New York.
Ambrose Clark, Long Island, N.Y.

357 *TROLLING FOR PIKE IN THE RIVER LEA
(Pair to No. 356.)
Canvas. 13¼ × 16¾in. S&D J. Pollard 1831.
*repr.* Engraved by G. Hunt and P. Himely.
*Angling in British Art* by W. Shaw Sparrow.
*exhib.* Viscount Allendale's Loan Exhibition of Sporting Pictures 1931.
*auct.* Christie's, 25th April 1940 (111).
A. N. Gilbey sale.
*lit.* *Animal Painters* by Sir W. Gilbey.
*coll.* A. N. Gilbey.
C. Dunlap, New York.
Ambrose Clark, Long Island, N.Y.

358 *BOTTOM FISHING
Panel. 13½ × 16in. Signed by J. Pollard.
*repr.* Engraved by R. G. Reeve.
*In the possession of Mr. Harry T. Peters, Jr., New York, U.S.A.*

359 ANGLERS PACKING UP
Panel. 13½ × 16in.
*repr.* Engraved by R. G. Reeve.

### 1833

360 FLY FISHING
Canvas. 11⅞ × 13¾in.
*repr.* Engraved by R. G. Reeve.

361★★TROLLING FOR PIKE ON THE RIVER LEA
Canvas. 11⅞ × 13¾in. Signed J. Pollard
*repr.* Engraved by R. G. Reeve.
*coll.* Hutchinson Gallery of Sporting Paintings.
*auct.* Christie's, 14th December 1951 (142).
*coll.* G. C. Paget, New York.

### 1834
362 ★PIKE AND ANCHOR INN, PONDERS END
Canvas. 11½ × 17½in. S&D J. Pollard 1834.
*auct.* Christie's, 25th April 1940 (114).
A. N. Gilbey sale.
*coll.* A. N. Gilbey.
*In the possession of Mr. Paul Mellon, U.S.A.*

### 1839
363 FISHING FOR TROUT AT THE PINCH OF
SNUFF INN, BEDDINGTON
Canvas. 8¼ × 12⅜in. S&D J. Pollard 1839.
*auct.* Christie's, 25th April 1940 (115).
A. N. Gilbey sale.
*coll.* A. N. Gilbey.

364★★PIKE FISHING AT HARLEYFORD-ON-
THAMES
Canvas. 11 × 15in. Signed J. Pollard.
*coll.* James Robert Pollard.
S. Dalziel.
*auct.* Sotheby's, 20th March 1963 (89).

### 1842
365★★PIKE FISHING ON THE RIVER LEA
An Angler in a top hat on a river bank.
Canvas. 10 × 12in. S&D J. Pollard 1842.
*auct.* Christie's, 25th April 1940 (117). Illustrated in
catalogue. A. N. Gilbey sale.
*coll.* A. N. Gilbey.

366 FLY FISHING FOR TROUT

367 LIVE BAIT FISHING FOR JACK (A pair)
9¼ × 12⅜in.
*repr.* Engraved by R. G. Reeve.

### 1843
368 TWO ANGLERS LIVE-BAIT FISHING FOR
PIKE
A train in the background.
7 × 10in. S&D. J. Pollard 1843.
*auct.* Christie's, 25th April 1940 (116).
A. N. Gilbey sale.
*coll.* A. N. Gilbey.

### 1846
369 ★ANGLING ON THE AVON, NEAR
FORDINGBRIDGE
13¾ × 17½in. Signed J. Pollard.
*In the possession of Mr. J. M. Schiff, New York.*

370 ★PIKE FISHING NEAR WALTHAM ABBEY
Panel. 7¾ × 10in. (Pair to No. 371.)

371 ★FLY FISHING FOR TROUT AT BEDDINGTON
CORNER
Panel. 7¾ × 10in. (Pair to No. 370.)

372 PIKE FISHING AT WALTHAM ABBEY
The Pike held on the gaff.
6⅝ × 7⅝in.
*auct.* Christie's, 25th April 1940 (113).
A. N. Gilbey sale.
*repr.* *Angling in British Art* by Shaw Sparrow.
*coll.* A. N. Gilbey.

373 TROUT FISHING AT BEDDINGTON
CORNER
9⅜ × 13¼in.
*auct.* Christie's, 25th April 1940 (119).
A. N. Gilbey sale.
*coll.* A. N. Gilbey.
*repr.* *Angling in British Art* by Shaw Sparrow.

### 1859
374– FISHING (A pair)
375 Panels. 11½ × 13½in. S&D J. Pollard 1859.
*exhib.* Frank Partridge Galleries, New York, 1959.
Illustrated in exhibition catalogue.

### Undated
376 PIKE FISHING
An Angler gaffing a Pike which the other has caught.
11 × 14¾in.
*auct.* Christie's, 25th April 1940 (118).
A. N. Gilbey sale.
*coll.* A. N. Gilbey.

377 PIKE FISHING AT WALTHAM ABBEY
Panel. 6¼ × 9in. (Pair to No. 378.)
*auct.* Christie's, 25th April 1940 (112).
A. N. Gilbey sale.
*coll.* A. N. Gilbey.

378 TROUT FISHING AT BEDDINGTON
CORNER
Panel. 6¼ × 9in. (Pair to No. 377.)
*auct.* Christie's, 25th April 1940 (112).
A. N. Gilbey sale.
*coll.* A. N. Gilbey.

379 POWDER MILL LANE, WALTHAM ABBEY
Panel. 6⅝ × 7⅝in. (Pair to No. 380.)

380 PIKE FISHING
Panel. 5⅝ × 7⅝in. (Pair to No. 379.)

381 THE FERRY BOAT INN
Canvas. 9½ × 13½in.

382 PIKE FISHING

383 FLY FISHING ON THE RIVER LEA
(A pair).
On slate. 6¼ × 9in.
*auct.* Sotheby's, 23rd March 1966 (105).
*In the possession of Mr. J. Warner, Washington, D.C.,
U.S.A.*

384 FISH
Canvas. 12 × 14in.
*coll.* James Pollard.
*In the possession of Mrs. M. E. Ellis (Great grand-
daughter of the Artist).*

## COURSING

### 1824
385 *COURSERS TAKING THE FIELD AT
HATFIELD PARK
Canvas. 40½ × 56½in.
*repr.* Engraved by J. Pollard.
*exhib.* British Institution, 1824.
Century Association, New York, 1941.
*auct.* Christie's, 27th April 1917.
*coll.* Ambrose Clark, Long Island, N.Y., U.S.A.

## MISCELLANEOUS

### 1828
386 LONDON FIRE ENGINES
The Noble Protectors of Lives and Property.
Canvas. 20 × 30in.
*repr.* Engraved by R. G. Reeve.

### 1830
387 SMITHFIELD MARKET
Canvas. 17½ × 25½in. S&D J. Pollard 1830.
*repr.* Engraved by R. G. Reeve.
*coll.* Sir W. Gilbey.
*auct.* Christie's, 12th March 1910 (126).

### 1839
388 MATERNAL ANXIETY

389 MOTHERLY PROTECTION
Studies of a Mare and Foal.
*exhib.* Royal Academy, 1839.

### 1849
390 STAKES AND TROTTERS
A Race with a Butcher's Boy between Hampton
and Teddington.

391 THE IMPUDENT CHALLENGE
William IV and a Butcher's Boy in Bushey Park.
(A pair)
Panel. 10½ × 14in. S&D J. Pollard 1849.
*repr.* Similar subject, lightographs by H. Heath.
*coll.* Mrs. M. Boyce.
*auct.* Sotheby's, 2nd November 1966 (138, 139).

### 1850
392– THE ADVENTURES OF JACK RANDY (Set
395 of four)
The Adventures of a Hunter who escaped.
8¼ × 11in. S&D J. Pollard 1850.

### 1851
395A A RELIGIOUS SUBJECT
Canvas 10 × 8¼in. S&D J. Pollard 1851.
*In the possession of Mrs. M. E. Ellis (Great-grand-
daughter of the Artist).*

### 1852
396 MUSIC HATH CHARMS
A group of horses listening to music on a river bank.
Canvas. 18 × 24in. S&D J. Pollard 1852.
*coll.* James Pollard.
*In the possession of Mr. F. Jacobs (Great-grandson of
the artist).*

### 1853
397 HARVEST TIME
Canvas. S&D J. Pollard 1853.
*coll.* J. Donahue, New York.
*auct.* Parke-Bernet, 3rd November 1967 (319).

398 CATTLE
S&D J. Pollard 1853.
*coll.* John Gurney, Norwich.

399 A PONY RACE
Two children on ponies.
Canvas. 13½ × 17½in. S&D J. Pollard 1853.
*auct.* Sotheby's, 27th April 1966.
Christie's, 21st December 1967 (243).

1856

400 THE GUARDS RETURNING FROM THE
CRIMEA 1856
Canvas. 10¾ × 7⅞in.
*coll.* M. Spink.

Undated
401 ★SELF PORTRAIT (about 1830)
Canvas. 7 × 6in.
*coll.* Sir Abe Bailey.
*In the National Gallery of South Africa, Cape Town.*

402 BARNET HORSE FAIR
10½ × 15in.
*repr.* Lithograph.

403 THE QUEEN AND PRINCE ALBERT TAKING
AN AIRING IN HYDE PARK
8 × 10⅝in.
*repr.* Lithograph.

404 QUEEN VICTORIA ON HORSEBACK

405 QUEEN VICTORIA GOING TO THE
OPENING OF PARLIAMENT

406 QUEEN VICTORIA WITH CARRIAGES
AND ESCORT
Original Drawings in the Print Room, British
Museum.

407 CRICKET AT COPENHAGEN HOUSE
7 × 11in.

408 COPENHAGEN HOUSE, ISLINGTON
Canvas. 9¾ × 11½in.
*auct.* Sotheby's, 15th July 1964 (144).

409 A CRICKET MATCH AT NOTTINGHAM
*auct.* Christie's, 23rd July 1900 (95).

410 A GROOM AND HIS HORSE OUTSIDE
THE DOCTOR'S SURGERY
Panel. 6¼ × 9in.
*In the possession of Mr. J. Warner, Washington, D.C.,
U.S.A.*

411 THE WATCH HOUSE BY ST. PAUL'S
CHURCH, COVENT GARDEN
Canvas. 13 × 10½in.
*auct.* Sotheby's, 11th October 1967 (48). 21st
December 1967 (96).

412 A CHANCE ENCOUNTER
The Squire and a butcher's boy.
Canvas on panel. 9 × 12in.
*coll.* K. M. Watts.
*auct.* Sotheby's, 17th March 1971 (101).

413 LORD NELSON INN
Canvas. 8 × 11in. Date on frame 1859.
*In the possession of Mr. J. M. Schiff, New York, U.S.A.*

414 MILTON PLACE, ISLINGTON GREEN
Panel. 10 × 12in. Date on frame 1859.
*In the possession of Mr. J. M. Schiff, New York, U.S.A.*

# *Part 2*
# ENGRAVED WORKS

Engravings after oil paintings are indicated by a catalogue reference number.
Where a reference is not given the engraving is after a water colour or drawing.

**COACHING**

### 1812

COACHING
8 × 11in. each.
Engraved by J. Pollard.
Published by R. Pollard, 22nd June 1812.
(These were his first engravings.)

500    MAIL COACH

501    STAGE COACH

502    BAROUCHE

503    TANDEM

### 1815

504    CHANGING HORSES TO THE MAIL COACH
12¼ × 17¾in.
Engraved by R. Havell.
Published by R. Pollard, 15th August 1815.
Reissued by R. Lamb.

505    STAGE COACH & OPPOSITION COACH IN SIGHT
12¼ × 17¾in.
Engraved by R. Havell.
Published by R. Pollard, 15th August 1815.
In a later state the tail of the leading offside coach horse is docked.

506    ROYAL MAIL COACH
12¼ × 17¾in.
Engraved by R. Havell.
Published by R. Pollard, 20th October 1815.
*coll.*    N. C. Selway (*original water colour*).

507    STAGE COACH WITH THE NEWS OF PEACE
12¼ × 17¾in.
Engraved by R. Havell.
Published by R. Pollard, 20th October 1815.
Reissued 1832 with title altered to Stage Coach with News of Reform.
Also reissued by J. Watson 1819.

### 1816

508    STAGE COACH SETTING OFF
12¼ × 17¾in. Pair to the following print.
Engraved by R. Havell.
Published by R. Pollard, 29th May 1816.

509    ARRIVAL OF THE STAGE COACH
12¼ × 17¾in. Pair to the previous print.
Engraved by R. Havell.
Published by R. Pollard, 29th May 1816.
Reissued by R. Lamb.

### 1817

510    THE LIONESS ATTACKING THE HORSE OF THE EXETER MAIL COACH
9¼ × 14½in.
Engraved by R. Havell.
Published by R. Pollard, 17th February 1817.
*coll.*    W. T. Spencer (*original water colour*).
There is also an oil painting of this subject. Cat. No. 30.

511    THE LAST HOUR OF A CONTESTED ELECTION FOR M.P.
12¼ × 17¾in. Pair to the following print.
Engraved by R. Havell.
Published by R. Pollard, 3rd April 1817.

512    THE ELECTED M.P. ON HIS WAY TO THE HOUSE OF COMMONS
12¼ × 17¾in. Pair to the previous print.
Engraved by R. Havell.
Published by R. Pollard, 5th April 1817.

513    FOUR IN HAND
12¼ × 17¾in.
Engraved by R. Havell.
Published by R. Pollard, 26th November 1817

514    LIGHT POST COACH
12⅛ × 17½in.
Engraved by R. Havell.
Published by R. Pollard, 26th November 1817.
Reissued 1826 with the title Cambridge Safety Coach, 25th March 1826.
Similar design to oil paintings. Cat. Nos. 2, 3, 4 and 5.

515 STAGE COACH & OPPOSITION COACH IN
SIGHT
12¼ × 17½in.
Engraved by J. Pollard.
Published by R. Pollard & Sons, 27th March 1819.
Reissued by R. Lamb.

516 STAGE COACH PASSENGERS AT BREAK-
FAST
12⅛ × 17¾in. Pair to the following print.
Engraved by J. Pollard.
Published by R. Pollard & Sons, 27th March 1819.
coll. F. T. Sabin (original water colour).
Fine Art Society.

517 COTTAGER'S HOSPITALITY TO
TRAVELLERS
12 × 17¾in. Pair to the previous print.
Engraved by J. Pollard.
Published by R. Pollard & Sons, 27th March 1819.

518 PATENT STAGE COACH
12¼ × 17¾in.
Engraved by J. Pollard.
Published by R. Pollard & Sons, 1st June 1819.

1821
519 H.M. GEORGE IV TRAVELLING
View in Hyde Park.
11¼ × 16¾in.
Engraved by M. Dubourg.
Published by E. Orme, 1st January 1821.
Reissued 1831 with name altered to William IV.
coll. Durand-Ruel (original water colour).
exhib. Knoedler, New York, November 1940.

1822
520 NEWMANS PATENT STAGE COACH
12⅛ × 17½in.
Engraved by J. Pollard.
Published by R. Pollard & Sons, 18th February 1822.
Reissued 1824 by R. Lamb.

521 STAGE COACH
11⅞ × 14⅞in. (see Cat. No. 8).
Engraved by M. Dubourg.
Published by J. Watson, 1st November 1822.

1823
522 TANDEM
12 × 15in. Pair to following print (see Cat. No. 9).
Engraved by J. Gleadah.
Published by J. Watson, 21st May 1823.

523 FOUR-IN-HAND
12 × 15in. Pair to previous print.
Engraved by J. Gleadah.
Published by J. Watson, 15th July 1823.

524 NORTH COUNTRY MAILS AT THE
PEACOCK, ISLINGTON
21½ × 30¾in. (see Cat. No. 6).
Engraved by T. Sutherland.
Published by J. Watson, 21st October 1823.
Reissued by T. Helme 1838.

1824
525 ROYAL MAIL COACH
Passing a country house.
12⅛ × 17½in. Pair to the following print.
Engraved by J. Pollard.
Published by R. Pollard & Sons, 1st January 1824.
Reissued by R. Lamb.

526 ROYAL MAIL COACH
Descending a hill.
12⅛ × 17½in. Pair to the previous print.
Engraved by J. Pollard.
Published by R. Pollard & Sons, 1st January 1824.

1825
527 FOUR-IN-HAND
16½ × 23¾in. (see Cat. No. 12).
Engraved by M. Dubourg.
Published by J. Watson, 14th September 1825.

528 THE MAIL COACH CHANGING HORSES
11 × 16in. One of a series of five (see Cat. No. 19).
Engraved by R. G. Reeve.
Published by J. Watson, 21st September 1825.

529 THE MAIL COACH IN A DRIFT OF SNOW
11 × 16in. One of a series of five (see Cat. No. 16).
Engraved by R. G. Reeve.
Published by J. Watson, 21st September 1825.
Also engraved by Himeley entitled
LE RETARD DE LA MALLE-POSTE
and by Jazet entitled
MALLE-POSTE ANGLAISE
A water colour drawing of the subject.
12 × 16½in. S&D J. Pollard 1821.
*In the possession of the National Gallery of South Africa.*

1826
530 THE ELEPHANT AND CASTLE ON THE
BRIGHTON ROAD
21¼ × 30½in. (see Cat. No. 24).
Engraved by T. Fielding.
Published by J. Watson, 7th February 1826.

531 STAGE COACH
8 × 15in.
Published by Dean and Munday, 1st March 1826.

532 PAIR HORSE SHORT STAGE COACH
12¼ × 17⅞in.
Engraved by J. Pollard.
Published by R. Pollard & Sons, 11th March 1826.

533 THE MAIL COACH IN A STORM OF SNOW
11 × 16in. One of a series of five (see Cat. No. 17).
Engraved by R. G. Reeve.
Published by J. Watson, 5th August 1826.
Original drawing sold at Christie's, 1969.

534 A STANHOPE WITH A FAVOURITE HORSE
11 × 16in. (see Cat. No. 27).
Engraved by T. Fielding.
Published by R. Lamb.

535 A VIEW OF REGENT'S PARK
11 × 16in. (see Cat. No. 28).
Engraved by W. Callow.
Published by R. Lamb.

536 A MORNING DRIVE TO THE GARDENS OF THE ZOOLOGICAL SOCIETY
11 × 16in. (see Cat. No. 29).
Engraved by W. Callow.
Published by R. Lamb.

1827
537 THE MAIL COACH IN A THUNDERSTORM ON NEWMARKET HEATH
11⅛ × 15⅞in. One of a series of five (see Cat. No. 23).
Engraved by R. G. Reeve.
Published by J. Watson, 21st May 1827.

538 THE MAIL COACH IN A FLOOD
10⅞ × 15¾in. One of a series of five (see Cat. Nos. 15 and 33).
Engraved by F. Rosenberg.
Published by J. Watson, 21st September 1827.

1828
539 STAGE COACH TRAVELLING
10⅞ × 15⅝in. (see Cat. No. 36).
Engraved by R. Rosenberg.
Published by J. Watson, 7th March 1828.

540 HYDE PARK CORNER
16½ × 24in. (see Cat. No. 40).
Engraved by R. and C. Rosenberg.
Published by J. Watson, 27th June 1828.
Republished by Fores in 1844 as The Grand Entrance to Hyde Park.

541 WEST COUNTRY MAILS AT THE GLOUCESTER COFFEE HOUSE, PICCADILLY
20¾ × 29⅛in. (see Cat. No. 37).
Engraved by C. Rosenberg.
Published by T. McLean, 1828.

542 THE BIRMINGHAM TALLY-HO! COACHES
19⅞ × 29⅞in. (see Cat. Nos. 25 and 39).
Engraved by C. Bentley.
Published by J. Brooker, 1828.

543 THE ROYAL MAILS AT THE ANGEL INN ISLINGTON ON THE NIGHT OF HIS MAJESTY'S BIRTHDAY
20⅞ × 29⅛in. (see Cat. No. 38).
Engraved by R. G. Reeve.
Published by T. McLean.

544 THE PROCESSION OF HIS MAJESTY GEORGE IV TO ASCOT HEATH RACES
10 × 39¼in. (see Cat. No. 45).
Engraved by R. G. Reeve.
Published by T. McLean.

1829
545 MAIL COACH
8⅝ × 12¾in. Pair to the following print (see Cat. No. 46).
Engraved by F. Rosenberg.
Published by J. Watson, 30th March 1829.

546 STAGE COACH
8⅝ × 12¾in. Pair to the previous print (see Cat. No. 47).
Engraved by F. Rosenberg.
Published by J. Watson, 30th March 1829.

547 MAIL COACH IN A FOG
13 × 17⅝in. Pair to the following print (see Cat. No. 55).
Engraved by G. Hunt.
Published by T. McLean, 1829.

548 MAIL COACH BY MOONLIGHT
12¾ × 17¾in. Pair to the previous print (see Cat. No. 54).
Engraved by G. Hunt.
Published by T. McLean.

549 THE NEW GENERAL POST OFFICE 1829
13¾ × 25¾in. (see Cat. No. 52).
Engraved by J. Pollard.
Published by R. Pollard and sold by T. Knights.
Reissued by J. W. Laird, 1849.

550 WARWICK AND BIRMINGHAM COACH
13¾ × 17¼in. (see Cat. No. 57).
Engraved by G. Hunt (attrib.).
Reissued with the title Old Birmingham Coach.
Published by T. C. Lewis.

1830
551 THE ROYAL MAILS' DEPARTURE FROM THE GENERAL POST OFFICE, LONDON
16¾ × 24⅛in. (see Cat. No. 50).
Engraved by R. G. Reeve.
Published by J. Watson, February 1830.

552 THE ROYAL MAILS STARTING FROM THE GENERAL POST OFFICE, LONDON
16¼ × 24⅞in. (see Cat. No. 51).
Engraved by R. G. Reeve.
Published by T. McLean, 19th April 1830.
Reissued by Soffe, 1836.

1831
553 THE ROYAL MAILS PREPARING TO START FOR THE WEST OF ENGLAND
17 × 23¾in. (see Cat. No. 62).
Engraved by F. Rosenberg.
Published by J. Watson, January 1831.

554 APPROACH TO CHRISTMAS
14⅞ × 20½in. Pair to the following print (see Cat. No. 67).
Engraved by G. Hunt.
Published by J. Moore.

555 A MAIL IN DEEP SNOW
14⅞ × 20½in. Pair to the previous print (see Cat. No. 68).
Engraved by G. Hunt.
Published by J. Moore.

556 A VIEW ON THE HIGHGATE ROAD
15¾ × 20in. Pair to the following print (see Cat. No. 70).
Engraved by G. Hunt.
Published by J. Moore.

557 HIGHGATE TUNNEL
15¾ × 20in. Pair to the previous print (see Cat. No. 71).
Engraved by G. Hunt.
Published by J. Moore.

558 THE CAMBRIDGE TELEGRAPH
15⅜ × 20⅝in. (see Cat. No. 81).
Engraved by G. Hunt.
Published by J. Moore.

559 THE LIVERPOOL UMPIRE
13½ × 17⅞in. (see Cat. No. 75).
Engraved by G. Hunt.
Published by J. Moore.

560 MAIL BEHIND TIME
13¾ × 18in. Pair to the following print (see Cat. No. 66).
Engraved by R. G. Reeve.
Published by T. Helme, 30th November 1831.

1832
561 MAIL CHANGING HORSES
13⅝ × 17⅞in. Pair to the previous print (see Cat. No. 79).
Engraved by R. G. Reeve.
Published by T. Helme, 1st February 1832.

562 A NORTH EAST VIEW OF THE NEW GENERAL POST OFFICE
14¾ × 22¾in. (see Cat. No. 84).
Engraved by H. C. Pyall.
Published by S. W. Fores, 1832.
Reissued showing later types of private vehicles.

563 THE COACH AND HORSES, ILFORD
12⅜ × 17½in. Pair to the following print (see Cat. No. 85).
Engraved by R. G. Reeve.
Published by T. Helme, 9th April 1832.

564 THE EAGLE, SNARESBROOK
12¼ × 17½in. Pair to the previous print (see Cat. No. 86).
Engravedby R. G. Reeve.
Published by T. Helme, 9th April 1832.

## 1835

**565 QUICKSILVER ROYAL MAIL**
13½ × 17⅛in. (see Cat. Nos. 88, 89 and 90).
Engraved by C. Hunt.
Published by Ackermann and Co., 1st November 1835.

**566 CAMBRIDGE COACH**
13⅞ × 17½in. Pair to the following print (see Cat. No. 94).
Engraved.
Published by T. Helme.

**567 MANCHESTER COACH**
13¾ × 17¾in. Pair to the previous print (see Cat. No. 95).
Engraved.
Published by T. Helme.

**568 FOUR IN HAND**
13⅜ × 17½in. Pair to the following print (see Cat. No. 96).
Engraved.
Published by T. Helme.

**569 TRAVELLING CARRIAGE**
14 × 17½in. Pair to the previous print (see Cat. No. 97).
Engraved.
Published by T. Helme.

**570 EDINBURGH, GLASGOW, MANCHESTER AND LONDON COACH**
13½ × 17⅞in. (see Cat. No. 99).
Reissued as The Edinburgh Express.

**571 LIVERPOOL, DERBY, MANCHESTER AND LONDON COACH**
13⅜ × 17⅞in. (see Cat. No. 100).

## 1837

**572 THE SNOW STORM—DELAY OF THE MAIL**
11 × 16⅛in. (see Cat. No. 105).
Engraved by R. G. Reeve.
Published by J. Watson, 1st January 1837.
(Also engraved in reverse by Himely with title in French).

**SCENES DURING THE SNOW STORM DECEMBER 1836 (A set of four)**
10 × 15in.
Lithographed by G. B. Campion.
Published by Ackermann and Co., 1st February 1837.

**573 THE DEVONPORT MAIL ASSISTED BY SIX FRESH POST HORSES** (see Cat. No. 106).

**574 THE LIVERPOOL MAIL IN A SNOW DRIFT** (see Cat. No. 107).

**575 THE BIRMINGHAM MAIL FAST IN THE SNOW** (see Cat. No. 108).

**576 THE LOUTH MAIL STOPPED BY THE SNOW** (see Cat. No. 109). Plate wrongly dated 1836. Reissued as Bowden's Coaching Recollections.

**577 THE TAGLIONI WINDSOR COACH**
11⅛ × 16in. (see Cat. No. 110).
Engraved by R. G. Reeve.
Published by J. Watson, 10th September 1837.

## 1838

**578 THE FOUR-IN-HAND CLUB, HYDE PARK**
14 × 21¾in. (see Cat. No. 111).
Engraved by J. Harris.
Published by Ackermann and Co., 1st December 1838.
Reissued by Dean, and also F. Watson.

**SCENES ON THE ROAD, OR A TRIP TO EPSOM AND BACK (A set of four)**
13 × 20in. each.
Engraved by J. Harris.
Published by Ackermann & Co., 30th May 1838.

**579 HYDE PARK CORNER** (see Cat. No. 115).

**580 THE LORD NELSON INN, CHEAM** (see Cat. No. 116).

**581 THE COCK AT SUTTON** (see Cat. No. 117).

**582 KENNINGTON GATE** (see Cat. No. 118).

## 1842

**583 THE DERBY DAY**
Tits and Trampers.
9⅝ × 14in.
Engraved by J. Harris.
Published by R. Ackermann, 25th March 1842.

Undated after 1840

COACHING SCENES
8¾ × 10¾in.
Lithographed by E. Hull and by Dean.
Published by Dean and Co. (see Cat. Nos. 161–167).

584 GOOD MORNING

585 THE SLEEPY GATEKEEPER

586 GOOD NIGHT

587 JUST IN TIME

588 MUSIC HATH CHARMS: to an old Hunter

589 HOLD-HARD!

590 WHEEL ON FIRE—Springing them up to meet
the Train
See also water-colours 867 & 868

## RACING

1816
591 SPECIMENS OF HORSEMANSHIP
(10 subjects on one plate).
3½ × 24½in.
Engraved by M. Dubourg.
Published by E. Orme, 1st November 1816.
Pair to *Shooting* 1816 (see Shooting subjects engraved).

592 MATCH FOR ONE THOUSAND GUINEAS!!!
'Sir Joshua' beating 'Filho-da-Puta'.
14 × 19in.
Engraved by R. Havell.
Published by R. Pollard, 1st July 1816.

593 'SIR JOSHUA' AND 'FILHO-DA-PUTA'
11¼ × 15in.
Engraved by Rosenberg.
Published by E. Orme, 1st July 1816.

1817
594 'DR. SYNTAX'
The Winner of Twenty Gold Cups!!!
12 × 17¾in.
Engraved by J. Pollard.
Published by R. Pollard, 5th January 1817.
Reissued 1822.

595 'THE STUDENT'
14 × 17in.
Engraved by R. Havell.
Published by R. Pollard.
*auct.* Original water colour, Sotheby's, 3rd May
1961.

1818–1819
596 EPSOM RACES

597 NEWMARKET RACES

598 ASCOT HEATH RACES (Set of three)
12 × 17in.
Engraved by J. Pollard.
Published by R. Pollard & Sons, 1. 29th April
1818; 2. 1st February 1819.
Reissued by J. Moore (undated).

599 'TIRESIAS'
12½ × 17½in.
Engraved by J. Pollard.
Published by R. Pollard & Sons, 6th July 1819.
*coll.* R. Pawsey (original water colour).

600 PONY RACE FOR ONE HUNDRED
GUINEAS
'Dandy' beat at Epsom by 'Mat o' the Mint'.
10 × 14in.
Published by R. Pollard & Sons, 22nd November
1819.

1821
601 'GUSTAVUS'
12½ × 17½in.
Engraved by J. Pollard.
Published by R. Pollard & Sons, 19th July 1821.

1822
602 'MOSES'
12½ × 17½in.
Engraved by J. Pollard.
Published by R. Pollard & Sons, 22nd June 1822.

RACING (Set of four)

603 TRAINING

604 AT THE POST

605 PREPARING TO START

606 RUNNING
4 × 14in.
Engraved by J. Pollard.
Published by R. Pollard & Sons, 20th September
1821; 5th March 1822.
and by J. Kendrick, Leicester Square.

607 'FIGARO'
12½ × 17½in.
Engraved by J. Pollard.
Published by R. Pollard & Sons.

608 TRAINING

609 STARTING

610 RUNNING

611 AFTER RUNNING
$8\frac{1}{2} \times 13\frac{7}{8}$in. (Set of four).
Engraved by G. Hunt.
Published by J. Watson, 5th February 1822.

### 1823

612 'EMILIUS'
$12\frac{1}{2} \times 17\frac{1}{2}$in.
Engraved by J. Pollard.
Published by R. Pollard & Sons, 8th July 1823.

613 'BAREFOOT'
$12\frac{1}{2} \times 17\frac{1}{2}$in.
Engraved by J. Pollard.
Published by R. Pollard & Sons, 20th October 1823.

614– HORSE RACING (Set of four)
617 $7\frac{1}{2} \times 10$in.
Engraved by J. Pollard.
Published by Dean and Munday.

### 1824

618 'CEDRIC'
$12\frac{1}{2} \times 17\frac{1}{2}$in.
Engraved by J. Pollard.
Published by R. Pollard & Sons, 1st July 1824.

619 'JERRY'
$12\frac{1}{2} \times 17\frac{1}{2}$in.
Engraved by J. Pollard.
Published by R. Pollard & Sons, 11th October 1824.

### 1825

620 DONCASTER—RACE FOR THE GREAT
ST. LEGER STAKES
$13 \times 26$in.
Engraved by J. Pollard.
Published by R. Pollard & Sons, 20th July 1825.

621 'MEMNON'
$12 \times 17$in.
Engraved by J. Pollard.
Published by R. Pollard & Sons.

622 'WINGS'
$13 \times 18\frac{3}{4}$in.
Engraved by J. Pollard.
Published by R. Pollard & Sons, June 1825.

623 'MIDDLETON'
$12\frac{1}{2} \times 17\frac{1}{2}$in.
Engraved by J. Pollard.
Published by R. Pollard & Sons, 14th June 1825.

624 THE SUBSCRIPTION ROOMS AT NEW-
MARKET

625 A VIEW ON THE ROAD TO NEWMARKET

626 TRAINING GROUND AT NEWMARKET

627 RACE FOR THE CLARET STAKES,
NEWMARKET
$7 \times 17\frac{1}{2}$in. each.
(Set of four.) (No. 4 was published in 1823.)
Engraved by J. Pollard.
Published by R. Pollard & Sons, (1) (2) (3) 7th
March 1825; (4) 29th May 1823.

### 1826

628 EPSOM RACE FOR THE GREAT DERBY
STAKES (see Cat. No. 180).

629 ASCOT HEATH RACE FOR HIS MAJESTY'S
GOLD PLATE (A pair)
$13 \times 25$in.
Engraved by J. Pollard.
Published by R. Pollard & Sons, 1st August, 1826.
Reissued by J. Moore.

### 1827

630 RACE FOR ONE THOUSAND POUNDS!!!
'Memnon' beating 'Enamel'.
Engraved by J. Pollard.
Published by R. Pollard & Sons, 2nd June 1827.

631 'MATILDA'
$12 \times 17\frac{1}{2}$in.
Engraved by J. Pollard.
Published by R. Pollard & Sons, 25th October 1827.

### 1828

632 'THE COLONEL'
$13 \times 17\frac{1}{4}$in. (see Cat. No. 181).
Published by T. McLean, 6th October 1828.

633 THE RACE FOR THE DERBY STAKES 1828
'Cadland' beating 'The Colonel'.
$13 \times 17$in. (see Cat. No. 182).
Engraved by R. G. Reeve.
Published by T. McLean.

**1829**

634 THE RACE FOR THE GOLD CUP AT ASCOT
14 × 18in. (see Cat. No. 183).
Engraved by J. Edge.
Published by T. McLean, 24th July 1829.

635 THE RACE FOR THE DERBY STAKES AT
EPSOM 1829
14 × 18in. (see Cat. No. 184).
Engraved by J. Gleadah.
Published by T. McLean, 20th June 1829.

**1831**

636 MR. G. OSBALDESTON RIDING HIS HORSE
AGAINST TIME AT NEWMARKET
13 × 17½in. (see Cat. No. 185).
Engraved by J. Pollard.
Published by T. Helme, 5th November 1831.
Reissued by B. Moss, 31st December 1852.

**1832**

637 DONCASTER RACES
Horses starting for the Great St. Leger Stakes.
13½ × 24½in. Pair to the following print (see Cat.
No. 186).
Engraved by Smart and Hunt.
Published by S. and J. Fuller, 1st June 1832.

**1833**

638 DONCASTER RACES
Passing the Judge's Stand.
13½ × 24½in. Pair to the previous print (see Cat.
No. 187).
Engraved by Smart and Hunt.
Published by S. and J. Fuller, 25th October 1833.

639 EPSOM RACES
The Race for the Derby Stakes.
14 × 25in. One of a set of three (see Cat. No. 188).
Engraved by H. Pyall.
Published by T. McLean, 1st November 1833.
Reissued 4th June 1834.

**1834**

640 GOODWOOD RACES
14 × 25in. One of a set of three (see Cat. No. 189).
Engraved by H. Pyall.
Published by T. McLean, 1st February 1834.

641 ASCOT RACES
'Glaucus' beating 'Rockingham' and 'Samarkand'.
14 × 25in. One of a set of three (see Cat. No. 190).
Engraved by H. Pyall.
Published by T. McLean, 4th October 1834.

EPSOM RACES (A pair)
14 × 24in. each (see Cat. Nos. 191–192).

642 NOW THEY'RE OFF
Start for the Derby Stakes.

643 HERE THEY COME
Passing Tattenham Corner.
Engraved by Smart and Hunt.
Published by S. and J. Fuller, 2nd June 1834.

**1835**

644 VIEW OF THE GRAND STAND,
DONCASTER
With portraits of the St. Leger Winners 1815–1834
14 × 24⅛in. (see Cat. No. 199).
Engraved by H. Pyall.
Published by T. McLean, January 1835.

**1836**

A PROSPECTIVE VIEW OF EPSOM RACES
(Set of six)
11¾ × 18¾in. each.
Engraved by C. Hunt.
Published by Ackermann & Co., 1st February 1836.
Reissued by Fores.

645 SADDLING IN THE WARREN (see Cat. No.
193)

646 THE BETTING POST (see Cat. No. 194)
Originally published 25th March 1835.

647 PREPARING TO START (see Cat. No. 195)

648 THE GRANDSTAND (see Cat. No. 196)

649 THE RACE OVER (see Cat. No. 197)

650 SETTLING DAY AT TATTERSALL'S (see Cat.
No. 198)

BRITISH HORSE RACING (Set of four)
10½ × 14½in. each.
Engraved by R. G. Reeve.
Published by T. McLean, 2nd November 1836.
Reissued by B. Moss 1852.

651 GOODWOOD GRAND STAND
Preparing to start (see Cat. No. 205).

652 DONCASTER GRAND STAND
Race for the Gold Cup (see Cat. No. 206).

653 ASCOT GRAND STAND
Coming in (see Cat. No. 207).

654 EPSOM GRAND STAND
The winner of the Derby Race (see Cat. No. 208).

### 1837

DONCASTER RACES—RACE FOR THE
GREAT ST. LEGER STAKES 1836 (Set of four)
15 × 25in. each.
Engraved by J. Harris.
Published by Ackermann & Co., 24th May 1837.

655   VEXATION—The False Start (see Cat. No. 200)

656   APPROBATION—Off in Good Style (see Cat. No. 201)

657   ANTICIPATION—Who is the Winner? (see Cat. No. 202)

658   JOY & DESPERATION—All over but Settling (see Cat. No. 203)

### 1839

659   RUN OFF OF THE ST. LEGER 1839
After the Dead Heat between 'Charles XII' and 'Euclid'.
(See Cat. No. 212).
Original drawing in Print Room, British Museum is marked 'Engraved'. No further details known.

660   RACE FOR THE DERBY STAKES AT EPSOM
12¾ × 18in.
Engraved by J. Pollard.

### 1842

THE DERBY PETS (Set of four)
12 × 17½in. each.
Engraved by J. Pollard.
Published by Ackermann & Co., 25th April 1842.

661   SALE OF THE COLT (see Cat. No. 214)

662   THE TRIAL (see Cat. No. 215)

663   THE ARRIVAL (see Cat. No. 216)

664   THE WINNER (see Cat. No. 217)

### 1843

665   MR. BOWES HORSE 'COTHERSTONE'
WINNING THE DERBY 1843 (see Cat. No. 219)
13 × 13in.
Lithographed and published by Dean & Co.

666   THE DESPERATE RACE FOR THE ST. LEGER
1843 (see Cat. No. 220)
13 × 13in.
Lithographed and published by Dean & Co.

### 1845

667   THE RACE FOR THE PLATE, THE GIFT OF
H.M. THE EMPEROR OF RUSSIA 1845
(see Cat. No. 221)
13 × 13in.
Lithographed and published by Dean & Co.

668   'THE MERRY MONARCH' (see Cat. No. 222)
The Property of Mr. Gratwick, Winner of the Derby 1845.
9¾ × 13½in.
Lithographed and published by Dean & Co.

### 1846

669   THE FIRST TIME OF SADDLING IN FRONT
OF THE GRAND STAND AT EPSOM 1846
(see Cat. No. 223)
13 × 13in.
Lithographed and published by Dean & Co.

670   DISMOUNTING IN THE ENCLOSURE AT
ASCOT 1846 (see Cat. No. 224)
13 × 13in.
Lithographed and published by Dean & Co.

671   'ALARM' (see Cat. No. 225)
The Property of Mr. Greville, Winner of the Emperor's Plate, Ascot, 1846.
9¾ × 13½in.
Lithographed and published by Dean & Co.

## ENGRAVED WORK AFTER CLIFTON THOMSON

### 1816

672   PANORAMIC VIEW OF BRITISH HORSE
RACING
The Race for the St. Leger 1812.
Engraved by Pollard and Dubourg, after Clifton Thomson of Nottingham
3¼ × 24¾in.
Published by E. Orme, 1st March 1816.

## WATER COLOURS NOT ENGRAVED

### 1836

673   DONCASTER RACES
12¾ × 23½in. S&D J. Pollard 1836.
*auct.*  Christie's, 22nd February 1966.

### Undated

674   GOODWOOD GRAND STAND
16½ × 19½in.
*auct.*  Christie's, 4th July 1924.

## STEEPLECHASING

### 1832

ST. ALBANS GRAND STEEPLECHASE
(Set of six)
8th March 1832.
12 × 17in. each (see Cat. Nos. 240–245).
Engraved by G. and C. Hunt, H. Pyall and C.
Bentley.
Published by J. Moore (with key).

675   THE TURF HOTEL AT ST. ALBANS
Engraved by G. and C. Hunt.

676   FIRST LEAP
Engraved by H. Pyall.

677   TURNING AN ANGLE
Engraved by C. Bentley.

678   STRUGGLE AT THE BANK
Engraved by H. Pyall.

679   WITHIN VIEW
Engraved by G. and C. Hunt.

680   THE WINNING POST
Engraved by G. and C. Hunt.

### 1833

681–  NORTHAMPTON GRAND STEEPLECHASE
686   (Set of six) (see Cat. Nos. 246–251).
12½ × 17in. each.
Engraved by H. Pyall.
Published by T. McLean (with key), 2nd September
1833.

### 1834

687–  ST. ALBANS TALLY-HO STAKES (A pair)
688   12 × 17in. each (see Cat. Nos. 252–253).
Engraved by G. and C. Hunt.
Published by J. Moore, 22nd May 1834.

### 1835

689   CAPTAIN BECHER ON 'VIVIAN' WINNING
THE OXFORDSHIRE GRAND STEEPLE-
CHASE
12½ × 17½in. Original drawing in Print Room,
British Museum marked 'Engraved'. No details
known.
(See Cat. No. 254.)

### 1836

690–  AYLESBURY GRAND STEEPLECHASE
693   The Light Weight Stake (Set of four).
14 × 20in. each (see Cat. Nos. 255–258).
Engraved by J. Harris.
Published by Ackermann & Co., 30th March 1836.

### 1837

694–  ST. ALBANS STEEPLECHASE (Set of four)
697   14 × 19in. each (see Cat. Nos. 259–262).
One engraved by R. G. Reeve (1), and three by C.
Hunt (2), (3), (4).
Published by J. Laird, 1st June 1837.

CHANCES OF THE STEEPLECHASE
(Set of eight: two 1839).
1–6 13¾ × 19in. each (see Cat. Nos. 263–268).
Engraved by Rosenberg and G. and C. Hunt.
Published by G. S. Tregear.
Reissued by Tregear and Lewis, and by Lewis and
Johnson, and by Lewis.

698   CAPTAIN BECHER AND 'VIVIAN'
Engraved by C. Rosenberg.

699   MR. SEFFERT AND 'MOONRAKER'
Engraved by C. Hunt.

700   MR. POWELL AND 'SALADIN' AT
AYLESBURY
Engraved by C. Rosenberg.

701   MR. COOPER AND 'THE PONY' AT
AYLESBURY 1836
Engraved by C. Rosenberg.

702   MR. SEFFERT AND 'GRIMALDI'
Engraved by C. Hunt.

703   MR. RICE AND 'RED DEER'
Engraved by G. Hunt.

### 1838

704–  ST. ALBANS GRAND STEEPLECHASE
707   (Set of four) (see Cat. Nos. 269–272).
12½ × 17in. each.
Published by T. Helme.

### 1839

CHANCES OF THE STEEPLECHASE
(Set of eight: six 1837).
7–8 13½ × 18½in. each (see Cat. Nos. 273–274).
No engraver's name.
Published by G. S. Tregear, 29th April 1839.
Reissued by Tregear and Lewis.
and by Lewis and Johnson, and by Lewis.

708   MR. MASON AND 'LOTTERY'
Winning at Liverpool.

709   MR. MARTIN AND 'PAULINA'
At Liverpool.

INCIDENTS OF THE STEEPLECHASE (A pair)
12¼ × 17½in. (see Cat. Nos. 276–277).

710 LIVERPOOL, 5th April 1840

711 CHELTENHAM 1840
Published by T. Helme.

## HUNTING

### 1816

712 SETTERS

713 TERRIERS

714 HOUNDS

715 POINTERS
Set of four. 7½ × 10in. 17th May 1816.
Published by R. Pollard, 3rd August 1816.

716– FOX HUNTING
717 EASTER HUNT (A pair)
3¼ × 24in.
Engraved by M. Dubourg.
Published by E. Orme, 29th September 1816.

### 1817

A CELEBRATED FOX HUNT (Set of four)

718 BREAKING COVER

719 THE CHASE

720 THE DEATH

721 RETURNING HOME BY MOONLIGHT
13 × 18in.
Engraved by R. Havell.
Published by R. Pollard, 1st July 1817.

### 1818

HUNTING WITH TERRIERS (Set of four)
5¾ × 8in.

722 TERRIERS AND RATS

723 FOX AND CUBS ATTACKED BY TERRIERS

724 TERRIERS AND WILD DUCK

725 POLECAT AND TERRIERS
Engraved by J. Pollard.
Published by Knight.

### 1820

726 KING GEORGE III HUNTING IN WINDSOR
PARK

727 H.M. GEORGE III RETURNING FROM
HUNT (A pair)
12⅛ × 17¾in. (see Cat. Nos. 281–282).
Engraved by M. Dubourg.
Published by E. Orme, 1st January 1820.

728 EASTER MONDAY: TURNING OUT THE
STAG AT BUCKHURST HILL, EPPING
FOREST

729 EASTER MONDAY: A VIEW OF FAIR MEAD
BOTTOM, EPPING FOREST (A pair)
12½ × 24in.
Engraved by J. Pollard.
Published by R. Pollard & Sons, 25th March 1820.

### 1822

HUNTING (Set of four)

730 UN-KENNELLING

731 THE FIND

732 FULL CRY

733 THE DEATH
4 × 14in.
Engraved by J. Pollard.
Published by R. Pollard & Sons, 5th March 1822.
Also Wm. Potter, Wrexham.

### 1829

734– TOM MOODY—THE WHIPPER IN (Set of four)
737 16 × 22in. (see Cat. Nos. 283–286). (With some
variations).
Engraved by G. Hunt.
Published 1st May 1829.
Reissued by B. Moss & Co., 1854.

738 POSTBOYS WATERING THEIR HORSES

739 HUNTERS ON THEIR WAY TO THE
STABLES (A pair)
14 × 17½in. (see Cat. Nos. 287–288).
Engraved by H. Pyall.
Published by T. McLean.

### 1840

740– THE JOLLY OLD SQUIRE (Set of four)
743 14⅞ × 20⅝in. (see Cat. Nos. 296–299).
Engraved by H. Papprill.
Published by Ackermann & Co., 2nd March 1840.
Reissued 1846.

FOX HUNTING (Set of four)
15¾ × 21¾in. (see Cat. Nos. 292–295).

744 FOX HUNTERS MEETING OUTSIDE AN INN

745 BREAKING COVER

746 FOX CHASE

747 THE DEATH
Engraved by C. Hunt.
Published by T. Helme.

### 1849
FOX HUNTING (Set of four)
10 × 14in. (see Cat. Nos. 306–309).

748 PUSH HIM AT IT SIR!

749 GALLANTLY DONE SIR!

750 ONE THAT CAN GO THE PACE

751 GOING IN AND OUT CLEVERLY
On stone by C. Dennis.
Published by Dean & Co., Threadneedle Street.

752– TOM MOODY (A pair)
753 9 × 13in. (see Cat. Nos. 324–325).
Lithographed by H. Heath, Junior.
Published by Dean & Co.

754 A CHIP OFF THE OLD BLOCK
10 × 14in. (see Cat. No. 311).
Lithographed by Sutcliffe.
Published by Dean & Co.

### Undated
755 A HUNTING PHAETON—A Party going to
Cover
12½ × 17½in. (see Cat. No. 328).
Engraved by C. Hunt.
Published by S. W. Fores.
*repr.* Frank T. Sabin catalogue of Sporting Prints,
1933.

FOX HUNTING (Set of four)

756 THE MEET
Waiting for the Governor.

757 THE DEATH
We have got him at last.

758 THE CHECK
Hark to Melody. Now at him again boys. Halloo!

759 REFUGE OF THE DESTITUTE
The last resource. Hounds at the Railway Station.
Drawings in the British Museum Print Room
marked 'Engraved'.
(See Cat. Nos. 320–323).

### 1819
### ENGRAVED WORKS AFTER E. GILL
FOX HUNTING (Set of four)

760 FOX HUNTERS MEETING

761 THE FOX BREAKING COVER

762 A FOX CHASE

763 DEATH OF THE FOX
12 × 17½in. After sketches by E. Gill.
Engraved by J. Pollard.
Published by R. Pollard & Sons, 12th November
1819.

### 1822
### ENGRAVED WORKS AFTER S. ALKEN
### J. N. SARTORIUS, J. POLLARD AND E. GILL
HUNTING (Set of four). (One after Pollard)

764 HUNTERS AT COVERT SIDE by S. Alken

765 BREAKING COVER by J. N. Sartorius

766 FULL CRY by J. Pollard

767 THE DEATH by E. Gill
*repr.* *British Sporting Artists* by W. Shaw Sparrow.
(1) (2) (3) *Old English Sporting Prints* by R.
Nevill.
15½ × 20½in.
Engraved by J. Pollard.
Published by S. Knight, 1st February 1822.

### SHOOTING
### 1812–1817
SHOOTING (A series of twelve)

768 DUCK SHOOTING 1812, 1st October

769 GROUSE SHOOTING 1812, 1st October

770 PHEASANT SHOOTING 1812, 21st November

771 WOODCOCK SHOOTING 1812, 21st November
*repr.* *Old English Sporting Prints* by R. Nevill.
Pl. XCVII.

772 PARTRIDGE SHOOTING 1812, 21st November

773 PIGEON SHOOTING 1813, 20th February

774 SEA-FOWL SHOOTING 1813, 20th February

775 MOORHEN SHOOTING 1817, 1st September

776 SNIPE SHOOTING 1817, 1st September

777 POACHER 1817, 6th February

778 WARRENER 1817, 16th February

779 EARTH STOPPER 1817, 1st September
Engraved by J. Pollard. 9⅝ × 14⅝in.
Published by R. Pollard.

## 1816

780 SHOOTING
(Ten subjects on one plate)
3½ × 24½in.
Engraved by M. Dubourg.
Published by E. Orme, 1st November 1816.
Pair to *Specimens of Horsemanship* (see Racing Subjects engraved).

## 1817

781 HIGH SPORT IN PURSUIT OF A HARE!!!

782 RETURNING HOME PRIMED AND LOADED
(A pair). 6½ × 8in.
Engraved by J. Pollard.
Published by R. Pollard, 1st September 1817.

## 1822

SHOOTING (Set of six)

783 PARTRIDGE

784 PHEASANT

785 GROUSE

786 PACKING UP

787 SNIPE

788 WILD DUCK
5½ × 16in.
Engraved by J. Pollard.
Published by Dean and Munday, 1st September 1822.
5 and 6 published 1st January 1825.
Three of the original drawings were sold at Sotheby's 12th February 1953, and No. 4 at Christie's 1969.

SHOOTING (Set of four)

789 GROUSE

790 SNIPE

791 PHEASANT

792 PARTRIDGE
9 × 14in.
Engraved by M. Dubourg.
Published by J. Watson, 15th June 1822.

SHOOTING (Set of four)

793 GROUSE SHOOTING

794 PARTRIDGE SHOOTING

795 PHEASANT SHOOTING

796 REFRESHING
4½ × 13½in.
Engraved by J. Pollard.
Published by R. Pollard & Sons, 2nd August 1822 and by J. Kendrick, Leicester Square.

## 1828

SHOOTING (A pair)

797 ANTICIPATION

798 POSSESSION
8¼ × 11in. (see Cat. Nos. 345-346).
Engraved by H. Pyall.
Published by J. Watson, 27th June 1828.
Reissued by Dean & Co.
(Issued with two after G. Jones).

A RE-ENCOUNTER IN A FARMYARD

PHEASANTS IN DANGER

## 1830

SHOOTING (Set of four)

799 PHEASANT

800 GROUSE

801 PARTRIDGE

802 WOODCOCK
13 × 17in. (see Cat. Nos. 347-350).
Engraved.
Published by T. Helme.

## 1822

### ENGRAVED WORKS AFTER A GENTLEMAN SPORTSMAN

803 MORNING OF THE FIRST OF SEPTEMBER

804 EVENING OF THE FIRST OF SEPTEMBER
(A pair)
14¼ × 18in.
Drawn by a Gentleman Sportsman.
Engraved by J. Pollard.
Published by R. Pollard & Sons, 17th October 1822.

## 1841

### ENGRAVED WORKS AFTER ALKEN

805 PARTRIDGE SHOOTING

806 GROUSE SHOOTING

807 WOODCOCK SHOOTING

808 PHEASANT SHOOTING
7 × 10½in. Drawn by Alken.
Engraved by J. Pollard.
Published by J. W. Laird 1841 (an earlier issue in existence).

## FISHING

### 1823

809– FISHING (A set of four)

812    $4\frac{5}{8} \times 13\frac{5}{8}$in.
*repr.* *Angling in British Art* by W. Shaw Sparrow.
Engraved by J. Pollard.
Published by R. Pollard & Sons, 21st June 1823.

### 1831

813– FLY FISHING

814    TROLLING FOR PIKE (A pair)
$13\frac{1}{4} \times 16\frac{1}{2}$in. (see Cat. Nos. 356–357).
Engraved by G. Hunt.
Published by J. Moore.
Also engraved by P. Himely.

815    BOTTOM FISHING

816    ANGLERS PACKING UP
(Two of a series of four with the following prints).
$13\frac{1}{2} \times 17\frac{1}{2}$in. (see Cat. Nos. 358–359).
Engraved by R. G. Reeve.
Published by T. Helme, 17th November 1831.

### 1833

817    FLY FISHING

818    TROLLING FOR PIKE
(Two of a series with the previous prints).
$13\frac{1}{2} \times 17\frac{1}{2}$in. (see Cat. Nos. 360–361).
Engraved by R. G. Reeve.
Published by T. Helme, 1st May 1833.

### 1842

819    FLY FISHING FOR TROUT

820    LIVE BAIT FISHING FOR JACK (A pair)
$9\frac{1}{4} \times 12\frac{1}{8}$in. (see Cat. Nos. 366–367).
'Dedicated to the members of the Waltonian Society by a Brother Angler'.
Engraved by R. G. Reeve.
Published by J. McCormick.

### 1849

821    PIKE FISHING
*repr.* *Sporting Magazine.*
Engraved by H. Beckwith.
Published by Rogerson.

### 1859

822    THE MILL FORD
*repr.* *Sporting Magazine.*
Engraved by J. Westley.
Published by Rogerson and Tuxford.

## COURSING

### 1821

823– COURSING (A set of four)

826    $3\frac{1}{2} \times 11\frac{1}{2}$in.
Engraved by J. Pollard.
Published by R. Pollard & Sons, 29th May 1821, 5th March 1822.

### 1822

827    FINDING

828    COURSING (A pair)
$8\frac{3}{4} \times 14$in.
Engraved by M. Dubourg.
Published by J. Watson, 1st July 1822.

### 1823

COURSING (A pair)

829    THE CHASE

830    THE DEATH
$5\frac{1}{2} \times 15\frac{7}{8}$in.
Engraved by J. Pollard.
Published by Dean and Munday, 14th September 1823.

COURSING

831    FINDING
$5\frac{1}{2} \times 15\frac{7}{8}$in.
Engraved by J. Pollard.
Published by Dean and Munday, 26th September 1823.

### 1824

832    COURSERS TAKING THE FIELD AT HATFIELD PARK (see Cat. No. 385).

833    COURSING—A VIEW IN HATFIELD PARK (A pair)
$10 \times 18$in.
*repr.* *A Book of Sporting Painters* by W. Shaw Sparrow.
*The Story of British Sporting Prints* by F. Siltzer (1st edition).
Engraved by J. Pollard.
Published by R. Pollard & Sons, 6th November 1824.

## ENGRAVED WORKS AFTER J. N. SARTORIUS

### 1821

COURSING (A set of four)

834  VIEW ON EPSOM DOWNS

835  VIEW ON EPSOM RACE COURSE

836  VIEW OF THE WARREN, EPSOM

837  VIEW OF LORD ARDEN'S, EPSOM
15⅜ × 20¼in.
Engraved by J. Pollard.
Published by S. Knight.
(Reissue published by T. Helme, 1833).

### MISCELLANEOUS

#### 1818

838  FAIRLOP FAIR
12 × 17½in.
Engraved by J. Pollard.
Published by R. Pollard, 24th April 1818.

839  BOXING MATCH FOR ONE HUNDRED POUNDS
Between John Randall and Edw. Turner, 5th December 1818.
10 × 15in.
Engraved by J. Pollard.
Published by S. Knight, 17th December 1818.

#### 1819

840  HACKNEY OLD CHURCH STEEPLE

841  HACKNEY NEW CHURCH (A pair)
10 × 12in.
Engraved by J. Pollard.
Published by R. Pollard, 1st January 1819.

#### 1820

842  THE CEREMONY OF THE PROCESSION AD MONTEM
12 × 18in.
Engraved by J. Pollard.
Published by R. Pollard & Sons, 20th July 1820.

#### 1821

843  FUNERAL PROCESSION OF QUEEN CAROLINE
9 × 22in.
Engraved by J. Pollard.
Published by Dean and Munday.

### 1822

LONDON MARKETS (Set of four)

844  MEAT MARKET

845  FISH MARKET

846  POULTRY MARKET

847  FRUIT MARKET
9 × 12in.
coll.  W. T. Spencer (original water colour drawings).
Engraved by M. Dubourg.
Published by E. Orme, 10th May 1822.

### 1823

HERON HAWKING (A pair)

848  HAWKING PARTY GOING OUT

849  HAWK STRIKING
8 × 10in.
auct.  Sotheby's, 12th February 1953 (the drawings).
Engraved by J. Pollard.
Published by Dean and Munday.

850  CRICKET

851  BOWLS (A pair)
3⅞ × 13¾in. Etchings.
Engraved by J. Pollard.
Published by R. Pollard & Sons, 9th August 1823.

### 1824

852  THE CRICKET MATCH
4½ × 16in.
Engraved by J. Pollard.
Published by Dean and Munday, 1st September 1824.

### 1825

853–  JOHNY GILPIN (Set of three)
855  8 × 12½in.
Engraved by J. Pollard.
Published by Dean and Munday, 26th August 1825.

### 1828

856  LONDON FIRE ENGINES
The Noble Protectors of Lives and Property.
20 × 30in. (see Cat. No. 386).
Engraved by R. G. Reeve.
Published by T. McLean.

857 CATTLE MARKET, SMITHFIELD, LONDON
17½ × 25in. (see Cat. No. 387).
Engraved by R. G. Reeve.
Published by T. McLean, 1831.

### 1849

858 THE IMPUDENT CHALLENGE
William IV and a Butcher Boy.
8½ × 12in. (see Cat. No. 391).
Lithographed by Heath.
Published by Dean & Co.

859 STAKES AND TROTTERS
A race with a Butcher Boy.
10 × 14in. (see Cat. No. 390).
Published by Dean & Co.

### Undated after 1840

860 THE QUEEN AND PRINCE ALBERT
TAKING AN AIRING IN HYDE PARK
8 × 10⅝in. (see Cat. No. 403).
Lithograph.

## ENGRAVED WORKS AFTER J. N. SARTORIUS

### 1816

861 TROTTING MATCH IN HARNESS AGAINST
TIME
16 × 21in.
Engraved by J. Pollard.

### 1824

862 'MAID OF THE MILL'
A Trotting Mare.
16 × 23in.
Engraved by J. Pollard.
Published by W. Giles.

## ENGRAVED WORKS AFTER
## S. EDWARDS AND J. POLLARD

### 1823–1826

FIGHTING COCKS (A set of four, (1), (3) and (4)
after S. Edwards).

863 'PHENOMENENON'
864 'THE CHESHIRE PILE'
865 'THE CHAMPION'
866 'YORKSHIRE HERO'
8½ × 8½in.
Engraved by J. Pollard.
Published by R. Pollard & Sons, (1) 15th March
1824; (2) 18th May 1826; (3) 16th April 1823; (4) 16th
April 1823.

## WATER COLOURS NOT ENGRAVED

867 MANCHESTER & DERBY COACH

868 THE SHEFFIELD HOPE (A pair)
Snow scenes (1830–1837)
12 × 17⅝in.
867 Signed J. Pollard.
*In the possession of Mrs. Bryant, Illova, Johannesburg.*

## ADDENDUM

869 THE LEEDS MAIL PASSING A TOLLGATE
Canvas 16½ × 20 in.
*auct.* Sotheby's, 9th June 1971 (75)

# ERRATA

Paintings illustrated and incorrectly attributed to James Pollard in the 1965 volume.

Cat. No. 85          *The Roadsters*, by Charles Hunt

    191          '*The Dey of Algiers*' *winning the Tradesmens Cup at Chester*, by William Tasker

    243          *The Grand National 1843*, by William Tasker

  276 and 277      *To the Meeting* and *In Full Cry*. Similar to engravings after James Pollard, but artist unidentified

# ILLUSTRATIONS

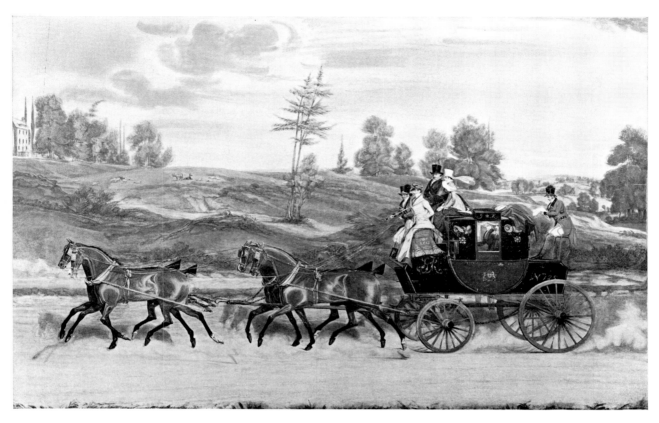

Cat. No. 20      THE MAIL COACH ON HIS MAJESTY'S BIRTHDAY      20 × 30in.
*In the possession of Mr. N. C. Selway*

Cat. No. 47      STAGE COACH—THE WONDER      8½ × 13in.
*In the collection of Mr. J. R. Dick, U.S.A.*

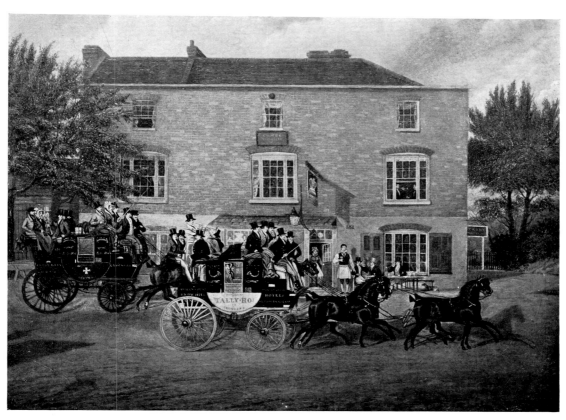

Cat. No. 39     THE BIRMINGHAM TALLY-HO COACHES PASSING     $17\frac{1}{2} \times 23\frac{1}{2}$in.
THE CROWN AT HOLLOWAY
*In the possession of Mr. J. H. Crang, Toronto, Canada*

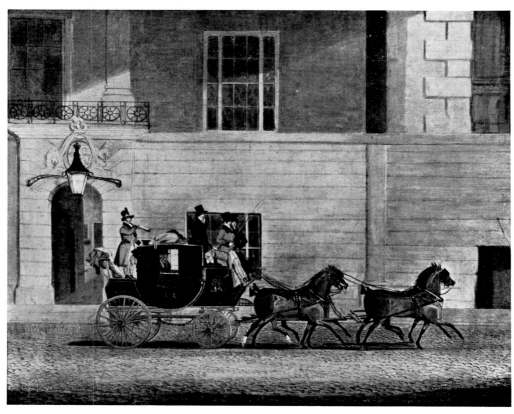

Cat. No. 31     THE SOUTHAMPTON MAIL AT THE OLD     $14 \times 17$in.
GENERAL POST OFFICE
*In the possession of Mrs. Rayner, New York, U.S.A.*

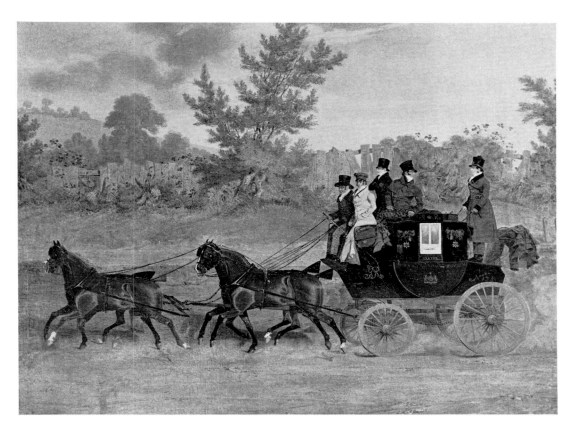

Cat. No. 2        THE EXETER ROYAL MAIL COACH        30 × 40in.
*In the possession of Mr. N. C. Selway*

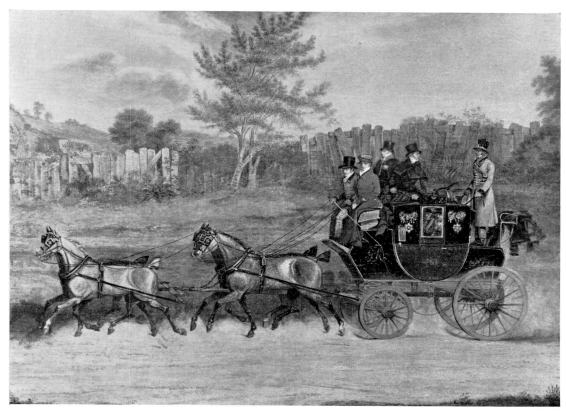

Cat. No. 4        THE HASTINGS ROYAL MAIL COACH        30 × 40in.

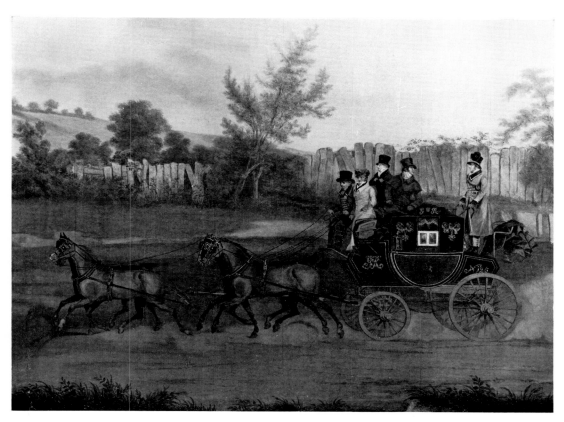

Cat. No. 5       THE BRISTOL ROYAL MAIL COACH       30 × 40in.

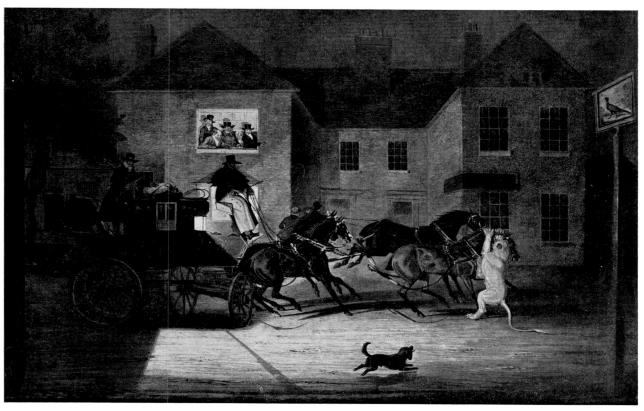

Cat. No. 30     THE LIONESS ATTACKING THE EXETER MAIL AT THE PHEASANT     20 × 30in.
INN, WINTERSLOW
*In the possession of Mr. N. C. Selway*

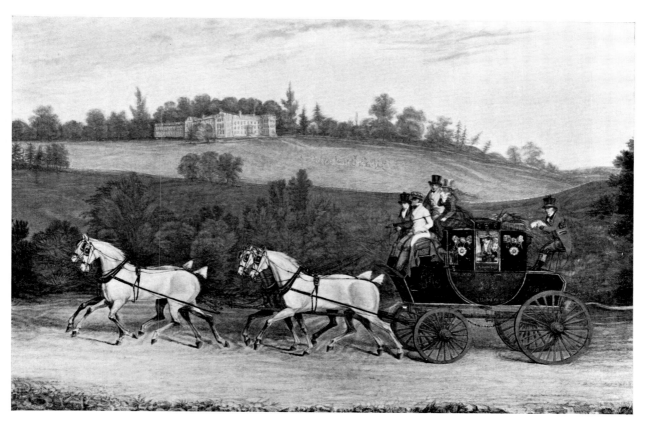

Cat. No. 22        THE NORWICH MAIL        20 × 30in.

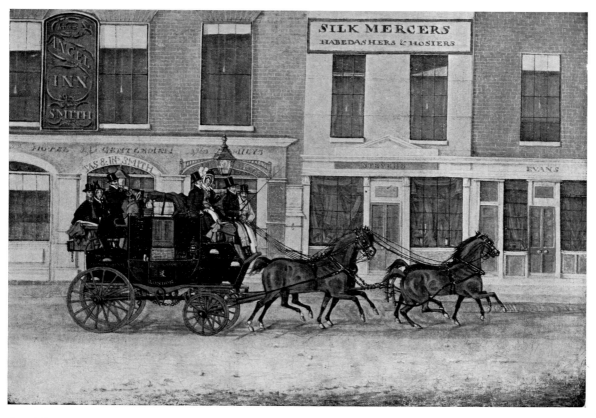

Cat. No. 48     THE BIRMINGHAM ECLIPSE AT THE ANGEL, ISLINGTON     12½ × 17½in.
*In the collection of Mr. J. R. Dick, U.S.A.*

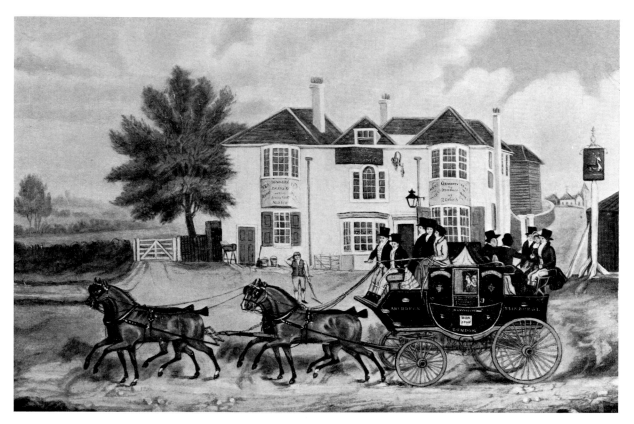

Cat. No. 49    THE ROYAL BRUCE PASSING THE BALD-FACED STAG, FINCHLEY    13½ × 19½in.
*In the possession of Mr. J. H. Crang, Toronto, Canada*

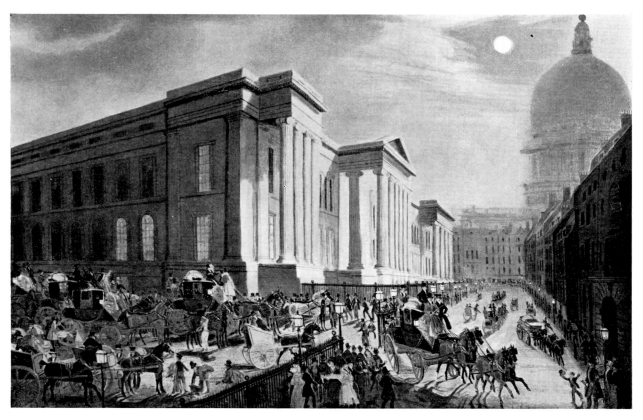

Cat. No. 51    THE ROYAL MAILS STARTING FROM THE GENERAL POST OFFICE    16 × 25in.
AT NIGHT
*In the possession of Mr. Charles H. Thieriot, New York, U.S.A.*

Cat. No. 56     THE BIRMINGHAM ECLIPSE AT THE BALD-FACED STAG,     14 × 18in.
FINCHLEY
*In the possession of Mr. P. Frelinghuysen, Washington, D.C., U.S.A.*

Cat. No. 59            MR. SHARP'S TANDEM            12 × 18in.

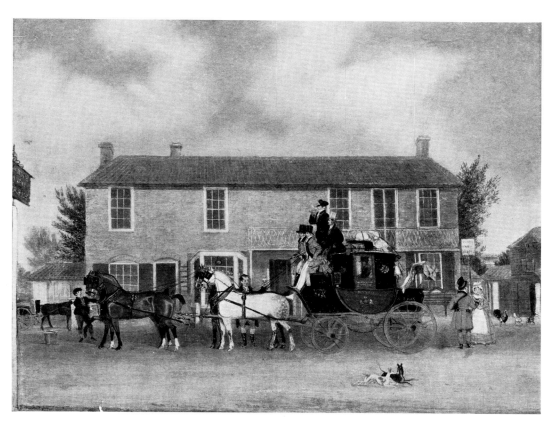

Cat. No. 60    THE NORWICH MAIL AT THE COACH AND HORSES,    14 × 17¾in.
ILFORD
*In the possession of Mr. N. C. Selway*

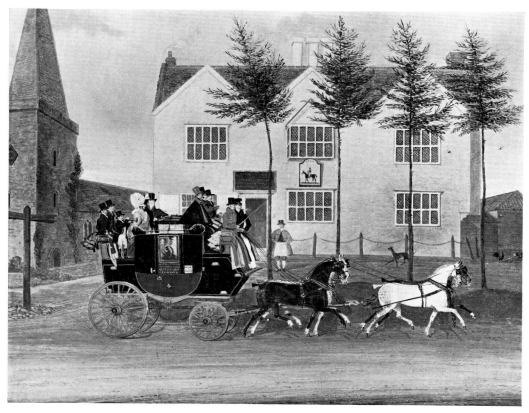

Cat. No. 63        THE GUILDFORD AND LONDON COACH        16 × 20½in.
*In the collection of Mr. J. R. Dick, U.S.A.*

Cat. No. 65　　　　　　　　BAROUCHE　　　　　　　$16\frac{1}{2} \times 21$in.
*In the collection of Mr. J. R. Dick, U.S.A.*

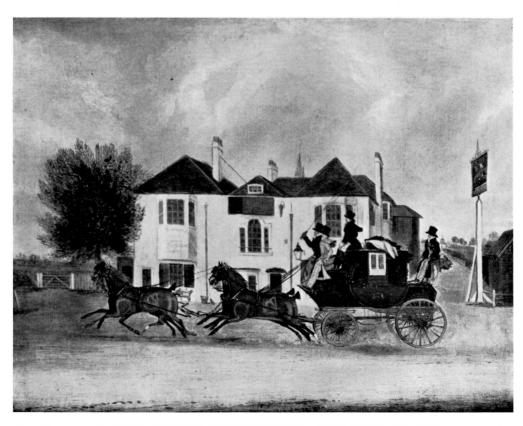

Cat. No. 66　A MAIL BEHIND TIME PASSING THE BALD-FACED　$14 \times 17$in.
STAG, FINCHLEY
*In the collection of Mrs. Rayner, New York, U.S.A.*

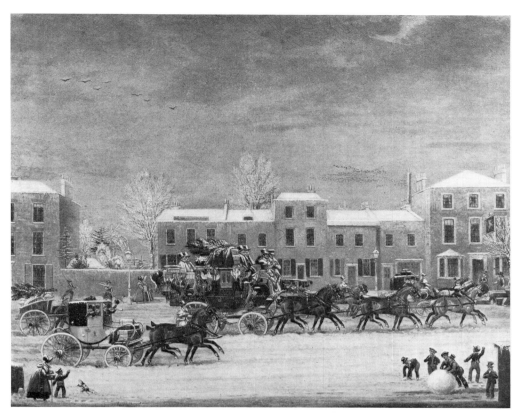

Cat. No. 67    APPROACH TO CHRISTMAS—THE NORWICH    17 × 21in.
TIMES IN THE MILE END ROAD
*In the collection of Mr. J. R. Dick, U.S.A.*

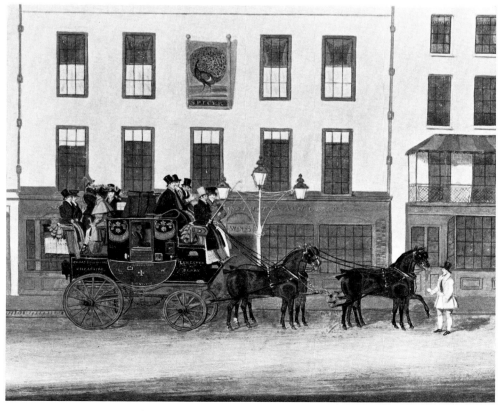

Cat. No. 100    THE PEVERIL OF THE PEAK OUTSIDE THE    14½ × 17½in.
PEACOCK INN, ISLINGTON

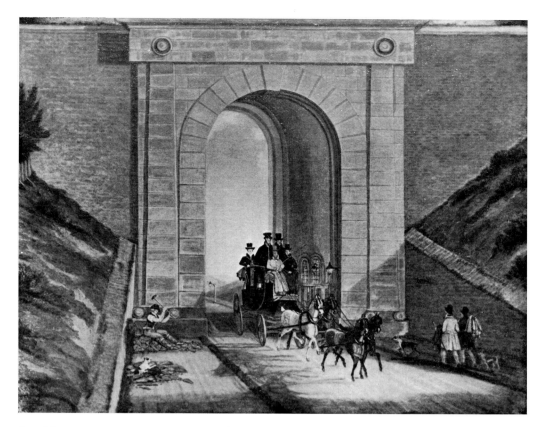

Cat. No. 70        HIGHGATE TUNNEL        17 × 21in.
*In the possession of Mrs. M. R. Hodson*

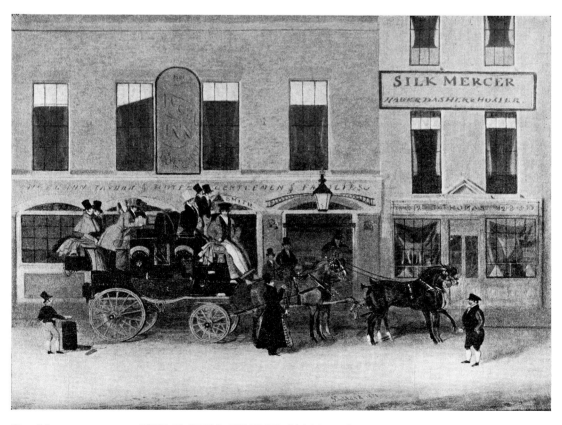

Cat. No. 71        THE ROYAL BRUCE AT THE ANGEL INN        13½ × 17½in.
*In the possession of Mr. J. M. Schiff, New York, U.S.A.*

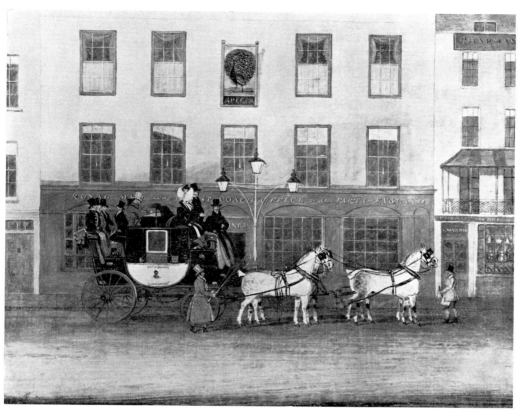

Cat. No. 72    THE LONDON AND LIVERPOOL COACH AT THE    14 × 17in.
PEACOCK, ISLINGTON
*In the collection of Mr. J. R. Dick, U.S.A.*

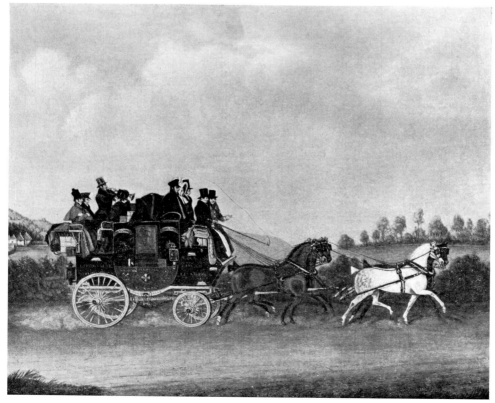

Cat. No. 74    THE LIVERPOOL UMPIRE    13½ × 16½in.
*In the collection of Mr. J. R. Dick, U.S.A.*

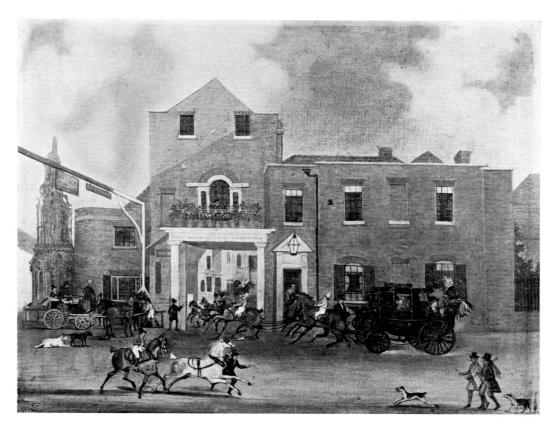

Cat. No. 77    A TRAVELLING CARRIAGE CHANGING HORSES AT    14 × 18in.
THE FALCON, WALTHAM CROSS

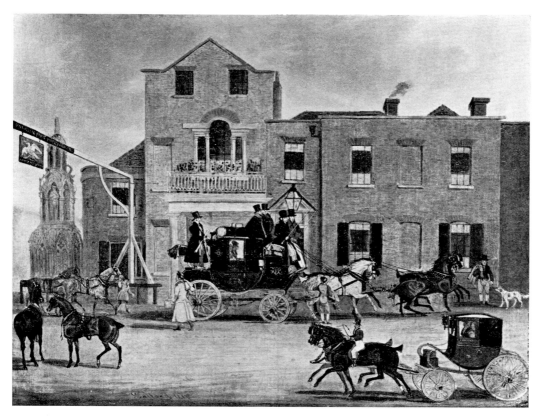

Cat. No. 79    THE HULL MAIL AT THE FALCON, WALTHAM CROSS    13½ × 17½in.

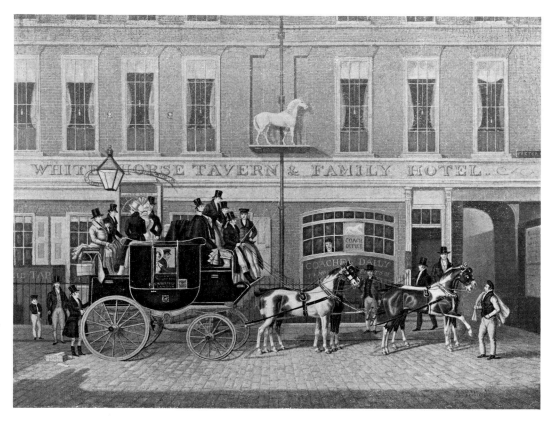

Cat. No. 80   THE CAMBRIDGE TELEGRAPH AT THE WHITE HORSE, FETTER LANE   16 × 21in.

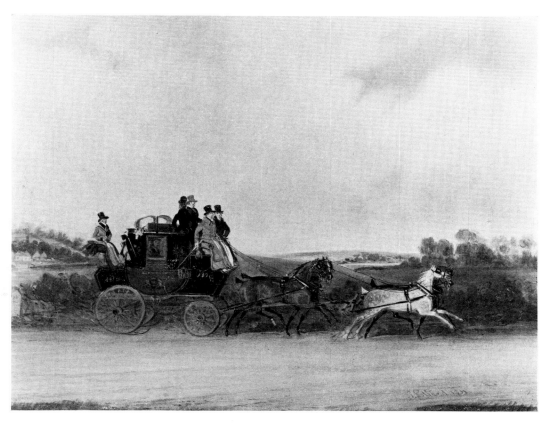

Cat. No. 81         THE SHEFFIELD MAIL         9½ × 12in.
*In the collection of Mr. J. R. Dick, U.S.A.*

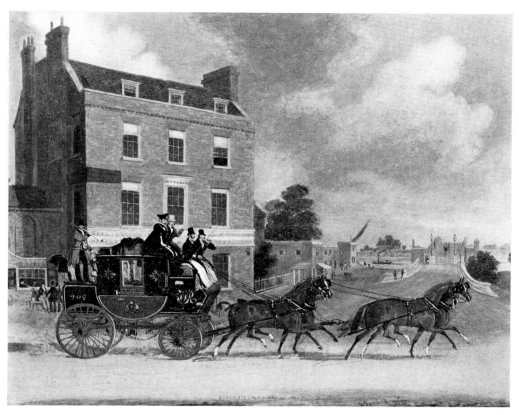

Cat. No. 88    THE QUICKSILVER ROYAL MAIL PASSING    $13\frac{1}{2} \times 17$in.
THE STAR AND GARTER AT KEW BRIDGE
*In the possession of Mrs. Ewing, New York, U.S.A.*

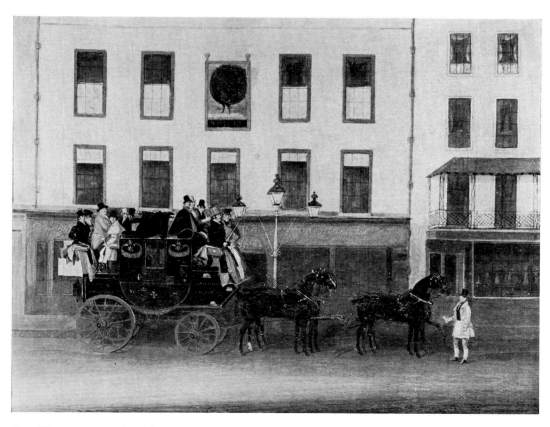

Cat. No. 90    THE PEVERIL OF THE PEAK OUTSIDE    $13\frac{3}{4} \times 17\frac{1}{2}$in.
THE PEACOCK, ISLINGTON
*In the collection of Mr. Paul Mellon, U.S.A.*

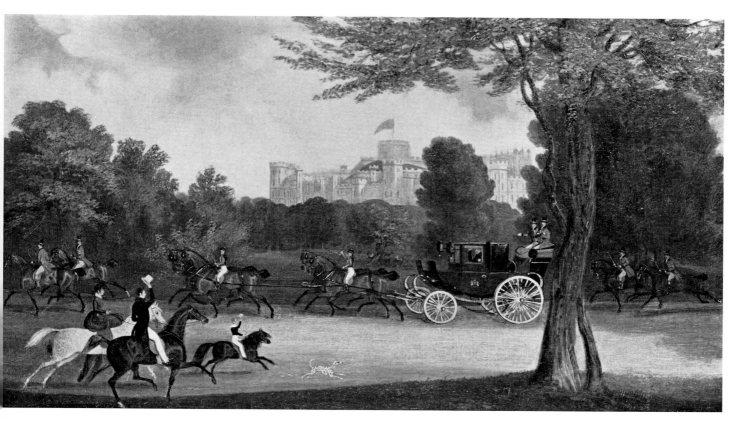

Cat. No. 92     H.M. KING WILLIAM IV DRIVING IN WINDSOR PARK     15 × 27in.
*In the possession of Mr. P. Kerr, New York, U.S.A.*

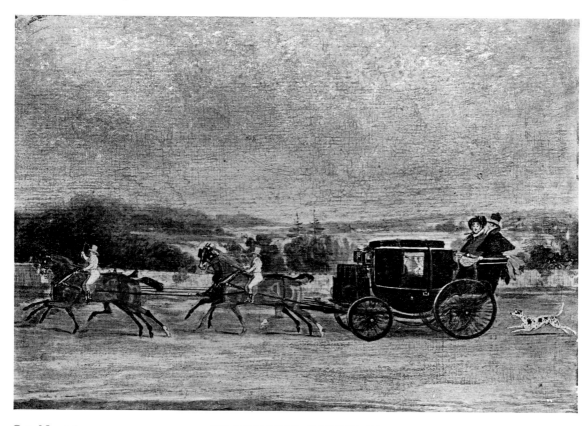

Cat. No. 96     TRAVELLING CARRIAGE     9¾ × 13½in.

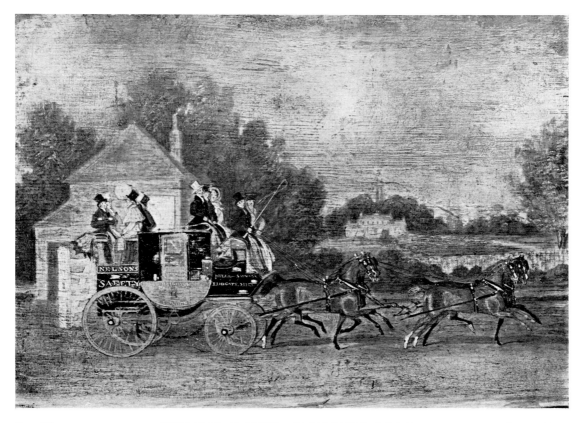

Cat. No. 97          THE RED ROVER BRIGHTON COACH          $9\frac{3}{4} \times 13\frac{1}{2}$in.

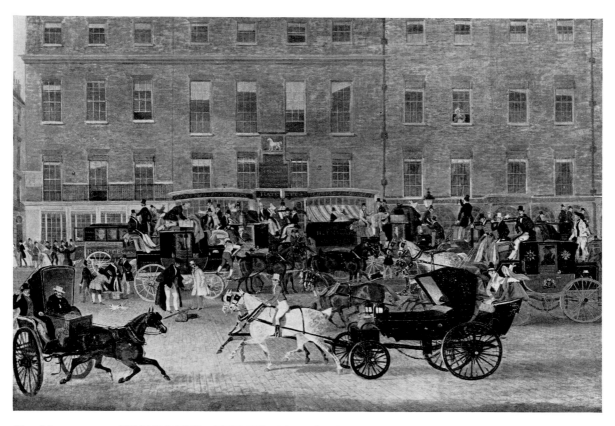

Cat. No. 102          HATCHETTS—THE WHITE HORSE CELLAR, PICCADILLY          $17\frac{1}{2} \times 25\frac{1}{2}$in.
*In the collection of Mr. J. R. Dick, U.S.A.*

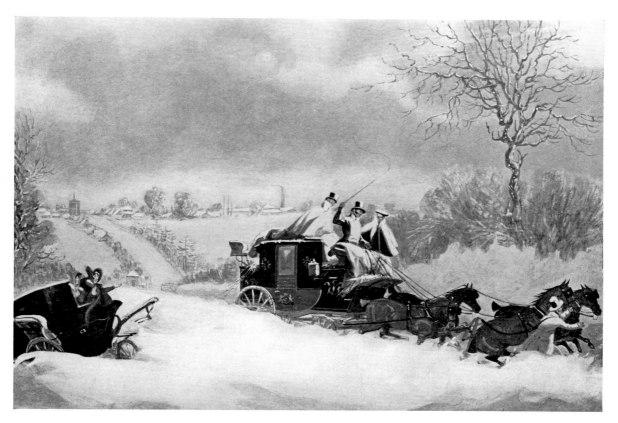

Cat. No. 107   THE LIVERPOOL MAIL IN A SNOW STORM NEAR ST. ALBANS   10 × 13in.
*In the collection of Mr. J. R. Dick, U.S.A.*

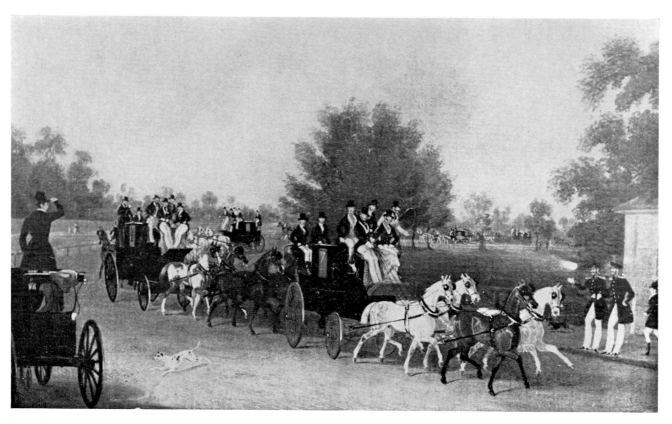

Cat. No. 111            THE FOUR-IN-HAND CLUB, HYDE PARK            14 × 22in.
*In the possession of The Royal Horse Guards*

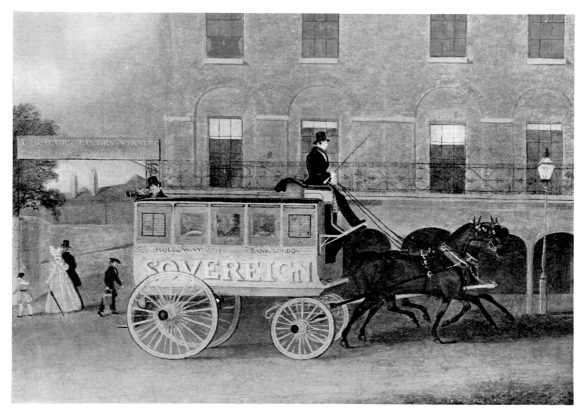

Cat. No. 112    HOLLOWAY AND THE BANK OMNIBUS SOVEREIGN    15 × 21 in.

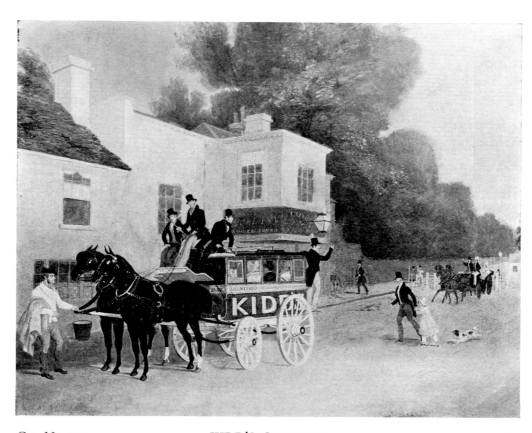

Cat. No. 114    KIDD'S OMNIBUS    20 × 24in.

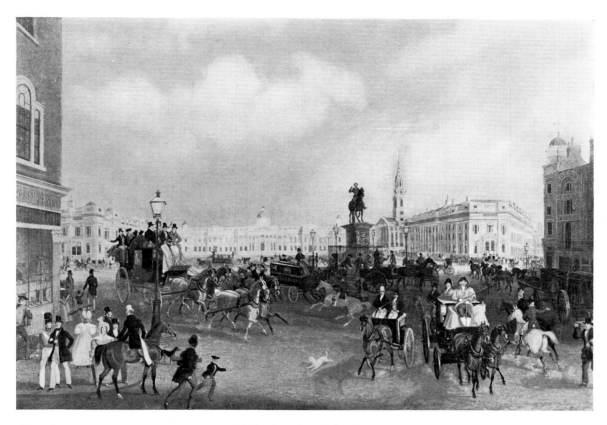

Cat. No. 113          TRAFALGAR SQUARE          21 × 31 in.
*In the collection of Mr. J. R. Dick, U.S.A.*

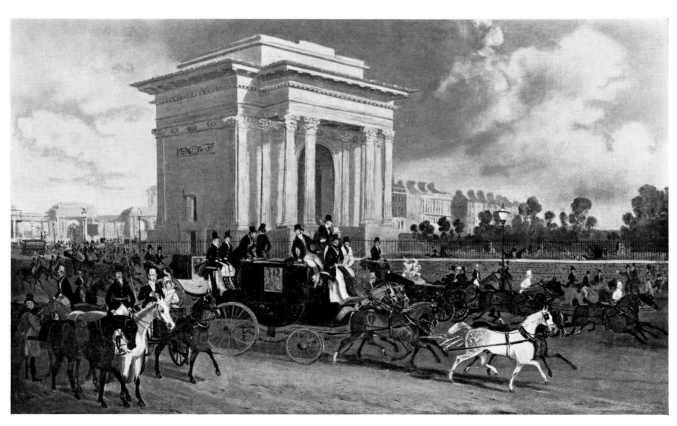

Cat. No. 115        A TRIP TO EPSOM—HYDE PARK CORNER        12 × 20 in.
*In the collection of Mr. J. R. Dick, U.S.A.*

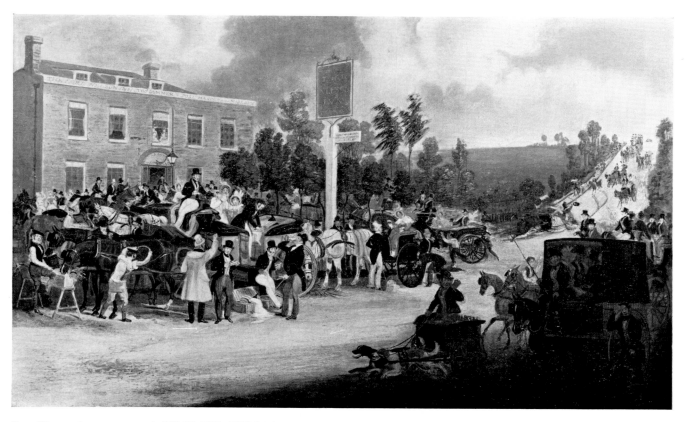

Cat. No. 116       A TRIP TO EPSOM—THE LORD NELSON INN AT CHEAM       12 × 20in.
*In the collection of Mr. J. R. Dick, U.S.A.*

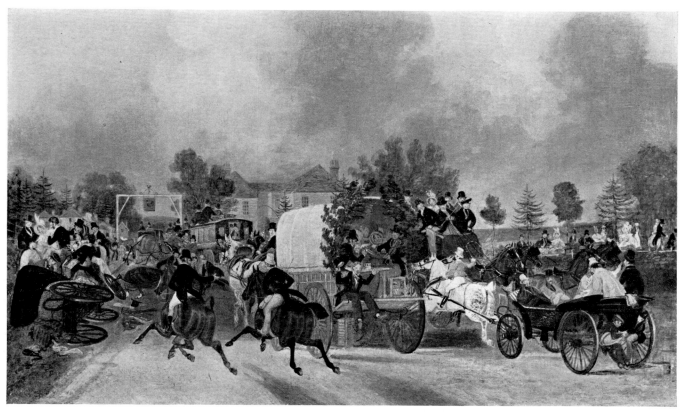

Cat. No. 117       A TRIP TO EPSOM—THE COCK AT SUTTON       12 × 20in.
*In the collection of Mr. J. R. Dick, U.S.A.*

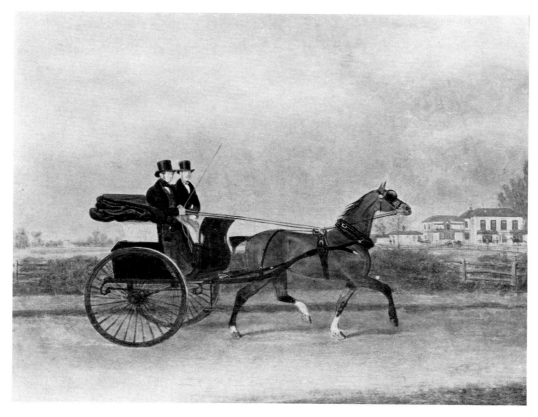

Cat. No. 119          DOG CART          17 × 21 in.
*In the collection of Mr. J. R. Dick, U.S.A.*

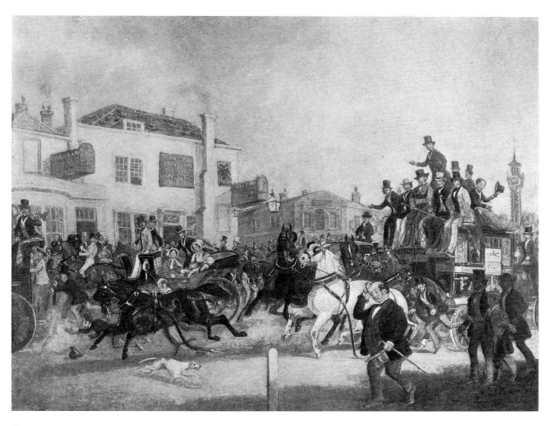

Cat. No. 120    GOING TO THE DERBY—THE SPREAD EAGLE, EPSOM

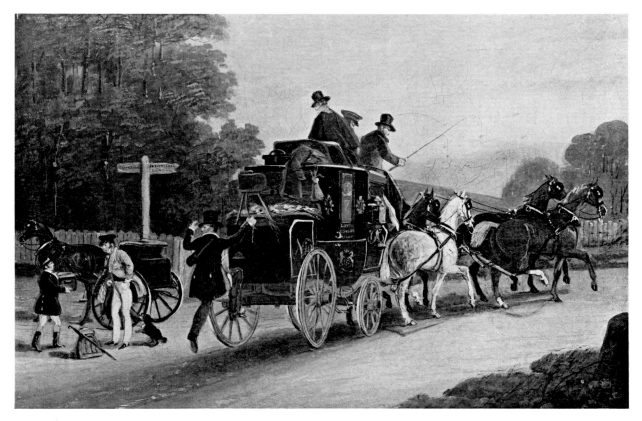

Cat. No. 137    THE LOUTH MAIL SETTING DOWN A PASSENGER    10 × 14in.

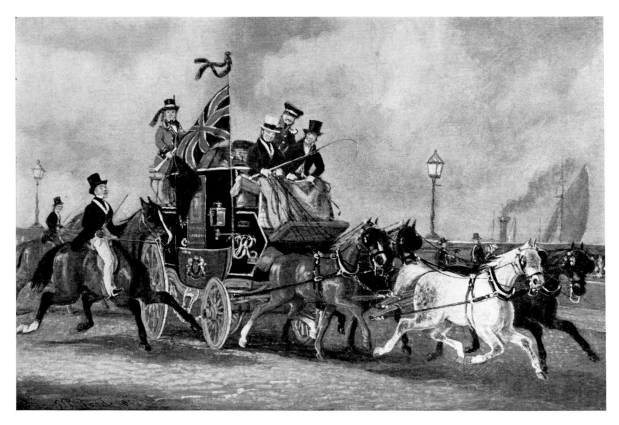

Cat. No. 138    THE LAST OF THE MAIL COACHES AT NEWCASTLE-UPON-TYNE    9 × 12in.

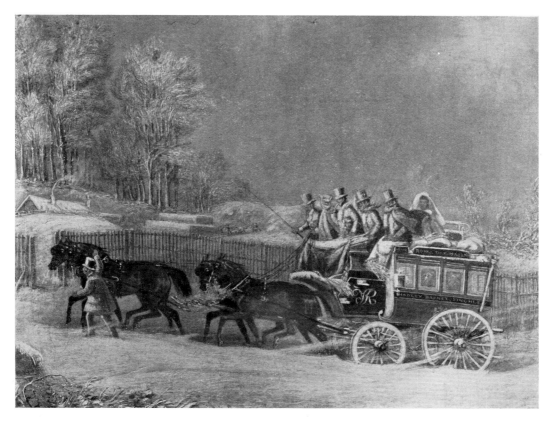

Cat. No. 140     ROYAL DAY MAIL IN WINTER     13 × 17in.

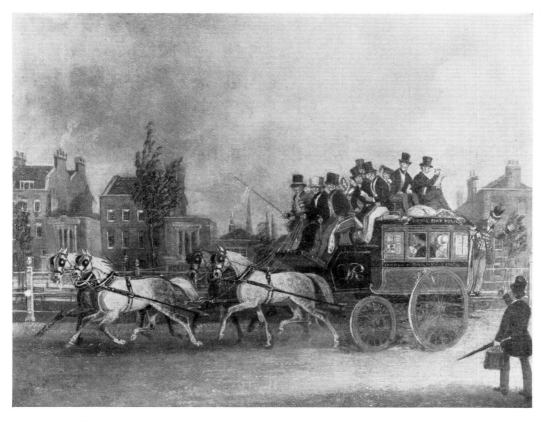

Cat. No. 141 ROYAL DAY MAIL IN SUMMER—PASSING ISLINGTON GREEN 13 × 17in.

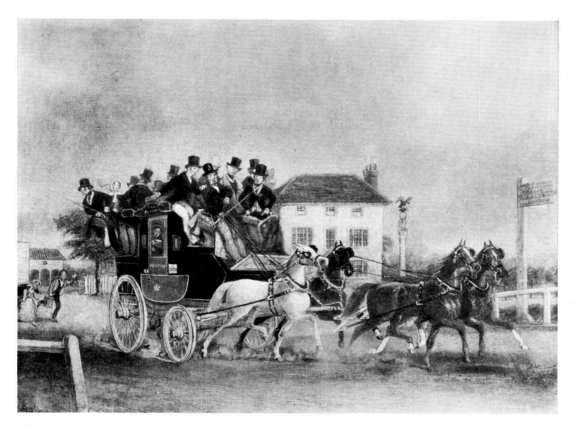

Cat. No. 142      THE WOODFORD COACH AT THE EAGLE,      13 × 17in.
SNARESBROOK

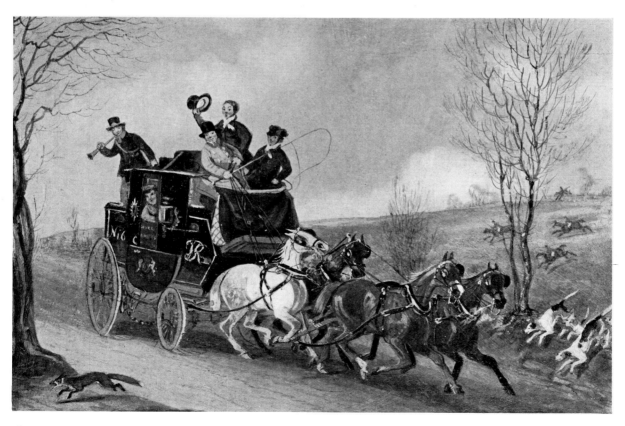

Cat. No. 147      THE HULL MAIL WITH THE HUNT IN FULL CRY      8½ × 12in.
*In the possession of Mr. D. A. C. Hutchison*

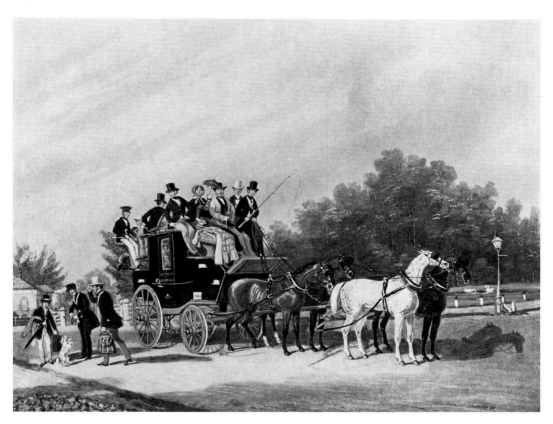

Cat. No. 149   FLACK'S CAMBRIDGE COACH AT STAMFORD HILL GATE   13 × 17in.
*In the possession of Mr. J. Story Smith, Pennsylvania, U.S.A.*

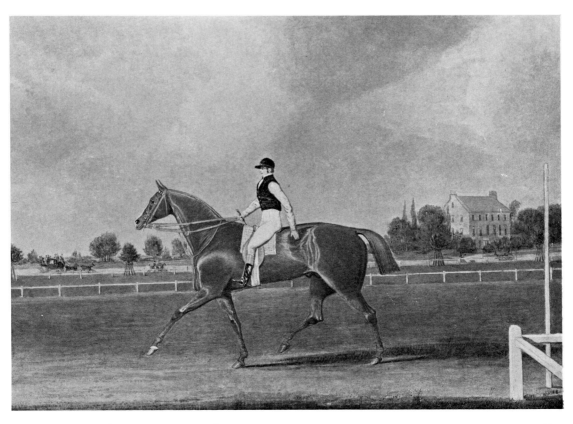

Cat. No. 181   'THE COLONEL'—WINNER OF THE ST. LEGER, 1828   13 × 17¼in.
*In the collection of Mr. J. R. Dick, U.S.A.*

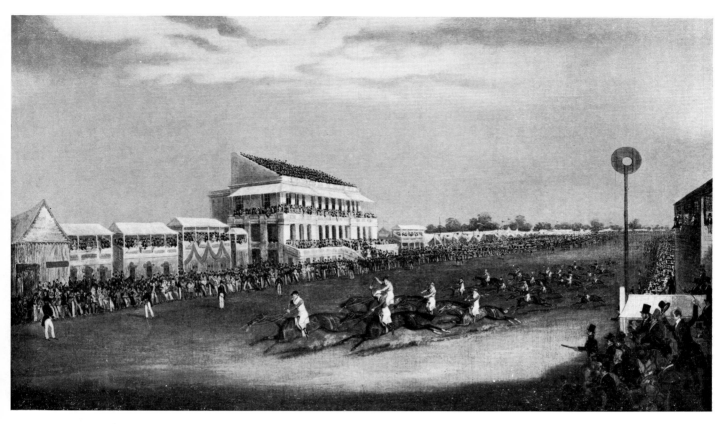

Cat. No. 188      EPSOM RACES—RACE FOR THE DERBY STAKES      14 × 25in
*In the possession of Mrs. M. E. Tippetts, Virginia, U.S.A.*

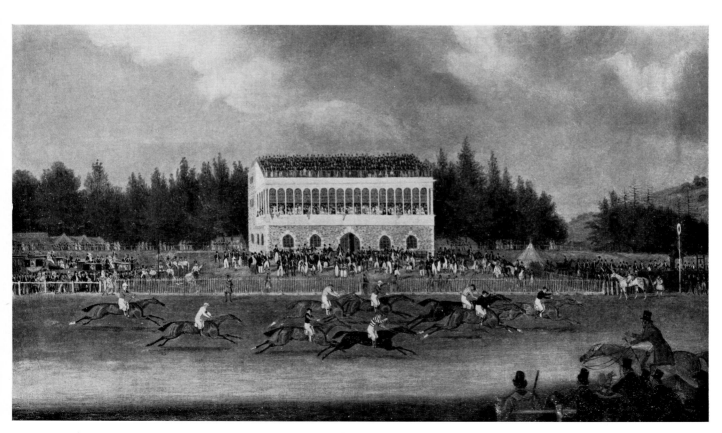

Cat. No. 189      GOODWOOD RACES      14 × 25in.
*In the possession of Mrs. M. E. Tippetts, Virginia, U.S.A.*

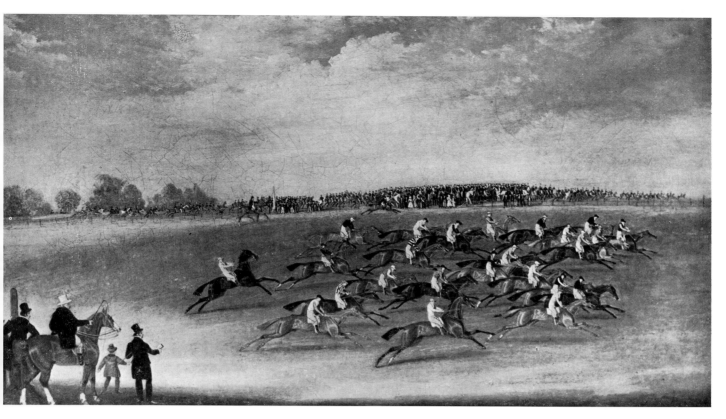

Cat. No. 191        THE START OF THE DERBY STAKES        14 × 24in.
*In the possession of Mr. Charles H. Thieriot, New York, U.S.A.*

Cat. No. 193        EPSOM RACES—SADDLING IN THE WARREN        11¾ × 18⅝in.
*In the possession of Mr. Charles H. Thieriot, New York, U.S.A.*

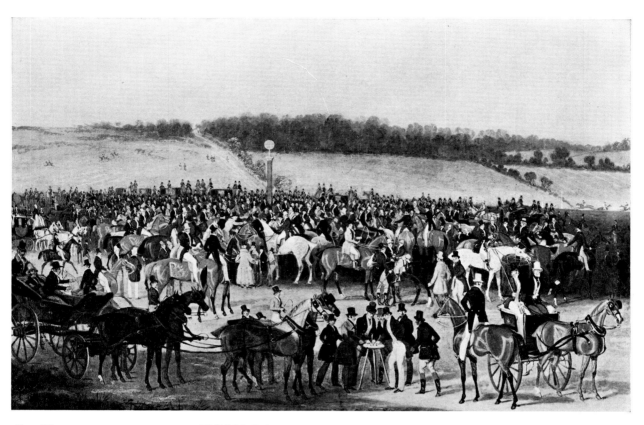

Cat. No. 194        EPSOM RACES—THE BETTING POST        $11\frac{3}{4} \times 18\frac{5}{8}$in.
*In the collection of* **Mr. J. R. Dick**, *U.S.A.*

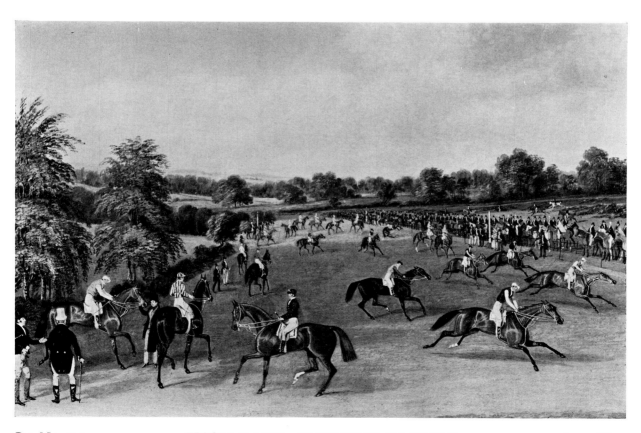

Cat. No. 195        EPSOM RACES—PREPARING TO START        $11\frac{3}{4} \times 18\frac{5}{8}$in.
*In the collection of* **Mr. J. R. Dick**, *U.S.A.*

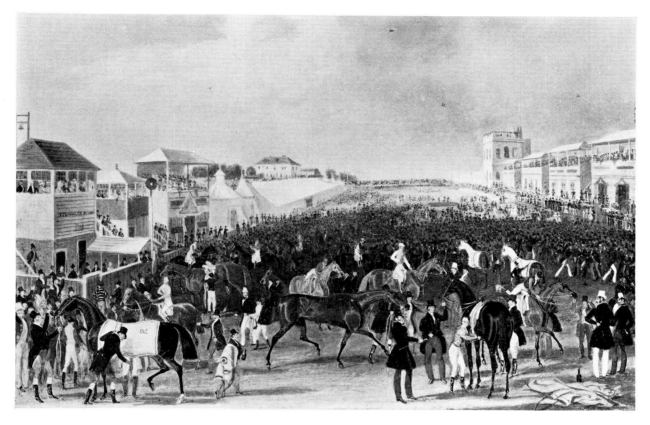

Cat. No. 197          EPSOM RACES—THE RACE OVER        $11\frac{3}{4} \times 18\frac{5}{8}$in.
*In the collection of Mr. J. R. Dick, U.S.A.*

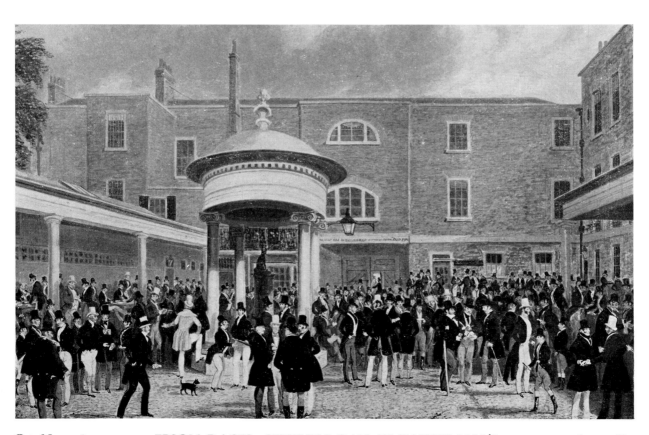

Cat. No. 198     EPSOM RACES—SETTLING DAY AT TATTERSALL'S     $11\frac{3}{4} \times 18\frac{5}{8}$in.
*In the collection of Mr. J. R. Dick, U.S.A.*

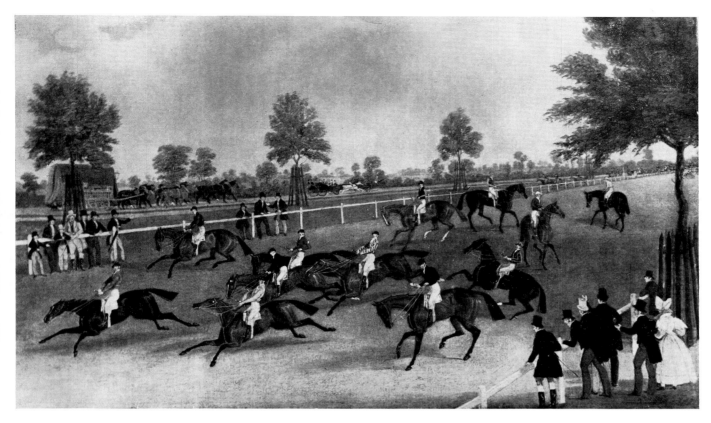

Cat. No. 200          THE ST. LEGER, 1836—THE FALSE START          15 × 25in.

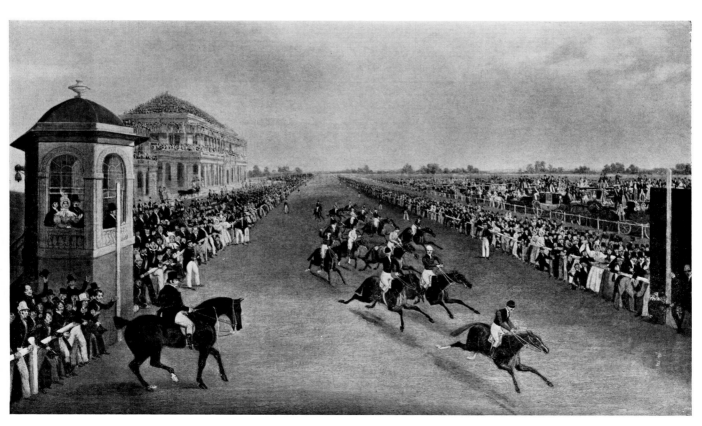

Cat. No. 202          THE ST. LEGER, 1836—WHO IS THE WINNER?          15 × 25in.

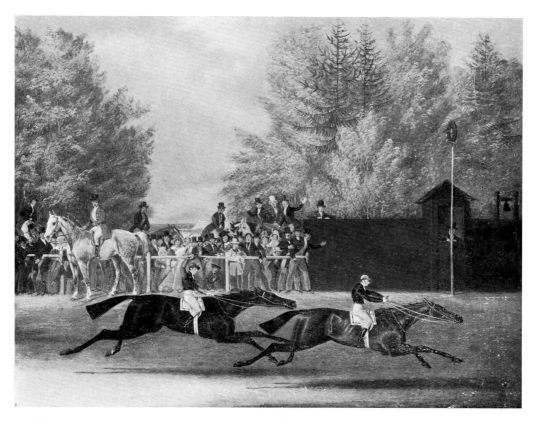

Cat. No. 209　THE KING'S PLATE, GOODWOOD 1837—'SLANE' BEATING 'ZOHRAB'　14 × 17½in.
*In the possession of Mr. T. W. Bullitt, Louisville, U.S.A.*

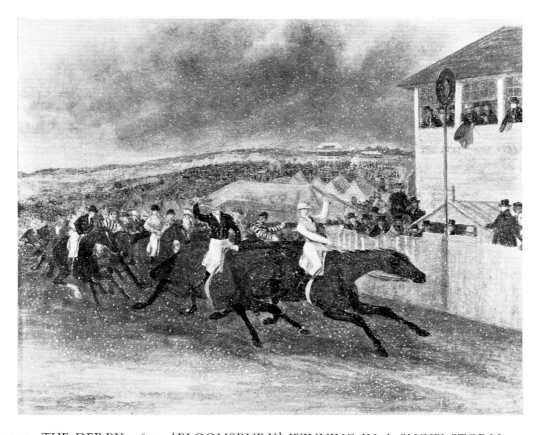

Cat. No. 211　THE DERBY, 1839—'BLOOMSBURY' WINNING IN A SNOW STORM　14 × 17½in.

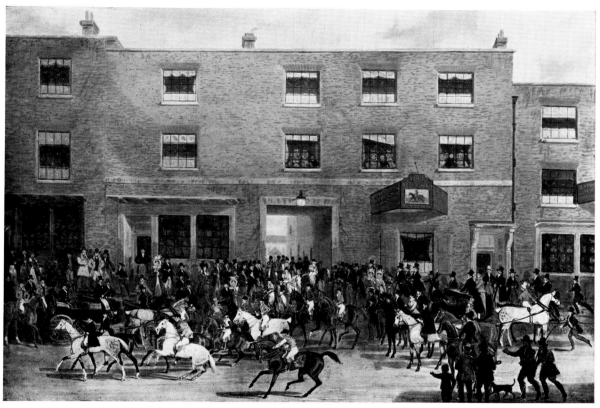

Cat. No. 240     ST. ALBANS GRAND STEEPLECHASE—THE TURF HOTEL,     12 × 17in.
ST. ALBANS
*In the possession of The National Trust of Scotland, Brodick Castle*

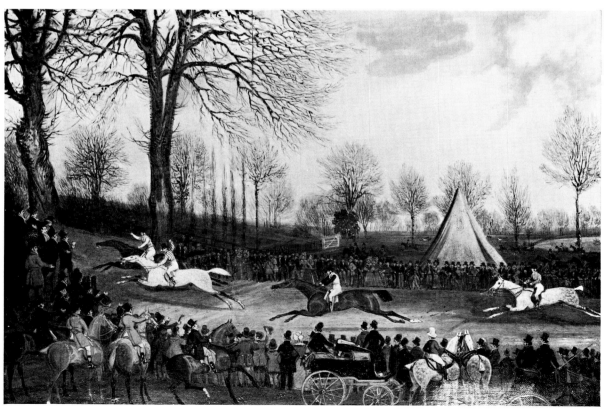

Cat. No. 245     ST. ALBANS GRAND STEEPLECHASE—THE WINNING POST     12 × 17in.
*In the possession of the National Trust of Scotland, Brodick Castle*

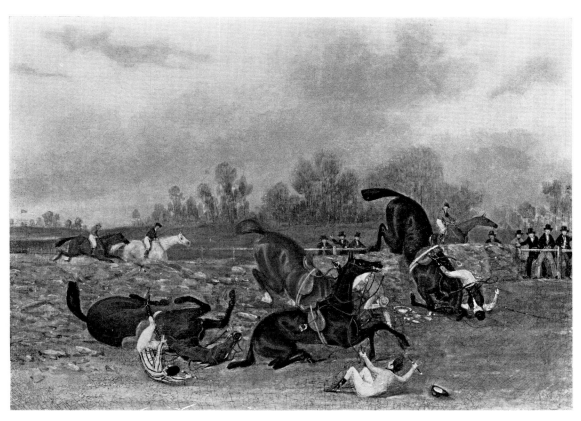

Cat. No. 276    INCIDENTS OF THE STEEPLECHASE—LIVERPOOL, 1840    12½ × 17in.
*In the Ambrose Clark Collection, U.S.A.*

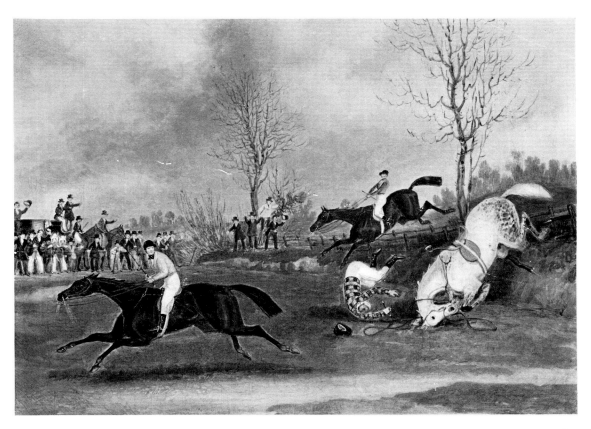

Cat. No. 277    INCIDENTS OF THE STEEPLECHASE—CHELTENHAM, 1840    12½ × 17in.
*In the Ambrose Clark Collection, U.S.A.*

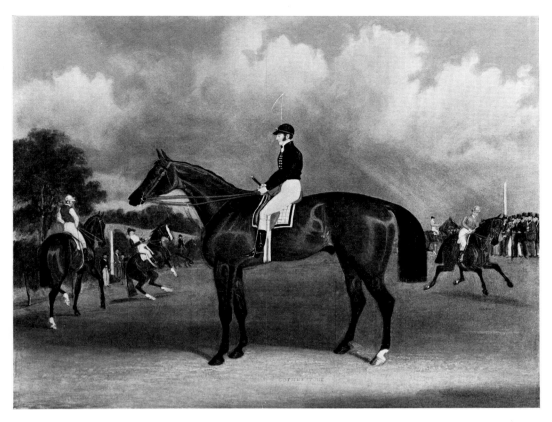

Cat. No. 218    'COTHERSTONE' WITH SCOTT UP, WINNER    $13\frac{1}{2} \times 17\frac{1}{8}$in.
OF THE DERBY, 1843

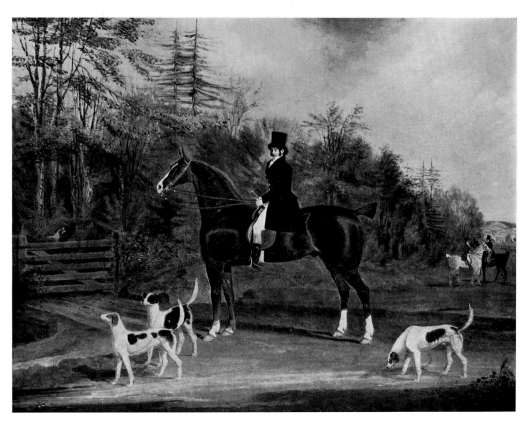

Cat. No. 280    EDWARD BROCKMAN ESQ. M.P. WITH THE    $22 \times 26\frac{3}{4}$in.
EAST KENT HOUNDS

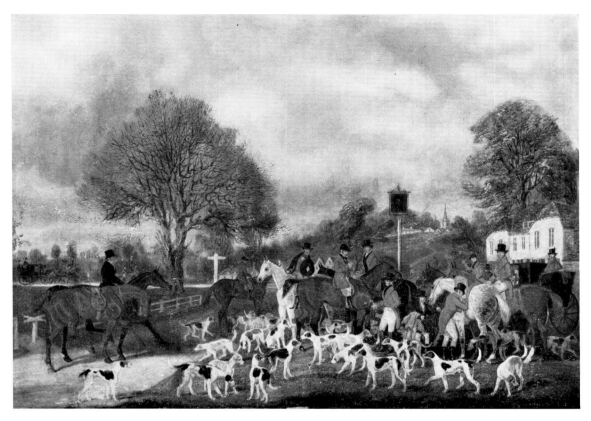

Cat. No. 292          FOX HUNTER'S MEETING          16 × 21¾in.

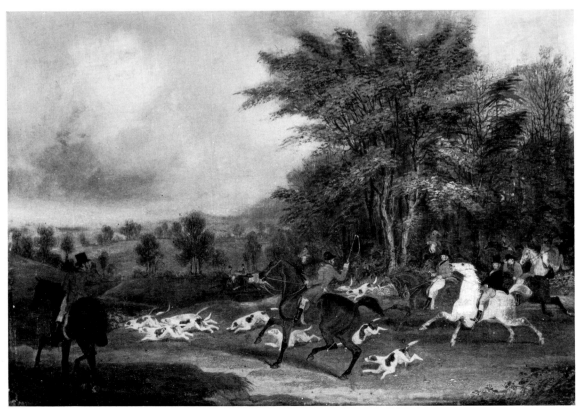

Cat. No. 293          BREAKING COVER          16 × 21¾in.

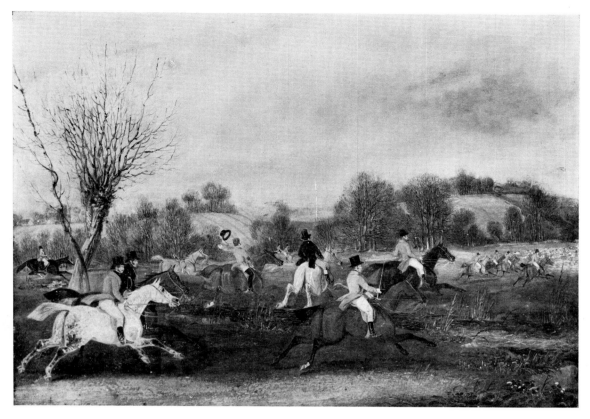

Cat. No. 294 FOX CHASE 16 × 21¾in.

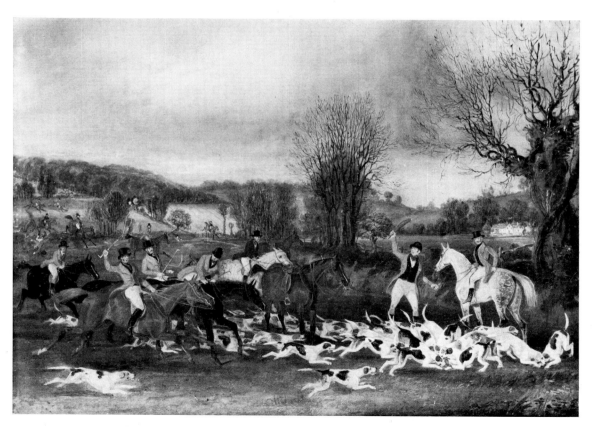

Cat. No. 295 THE DEATH 16 × 21¾in.

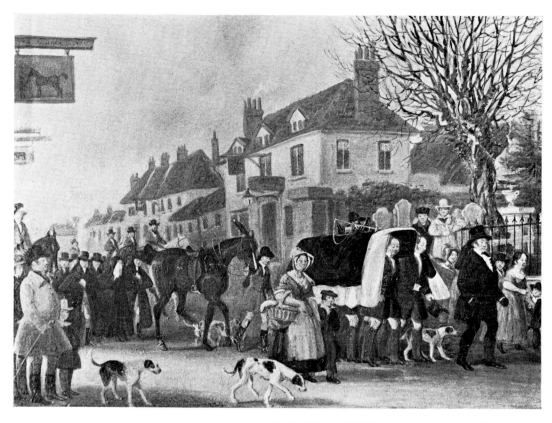

Cat. No. 286      THE FUNERAL OF TOM MOODY      $9\frac{3}{4} \times 10\frac{3}{4}$in.
*In the possession of The Marquess of Bute*

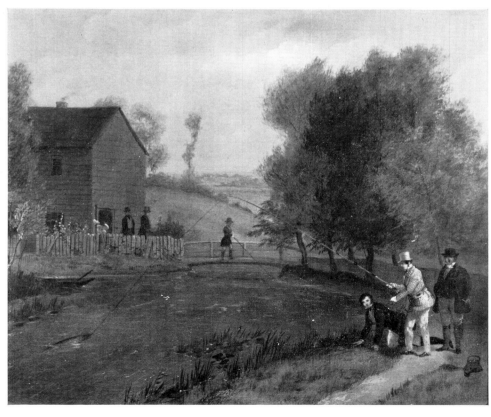

Cat. No. 361      TROLLING FOR PIKE ON THE RIVER LEA      $11\frac{7}{8} \times 13\frac{3}{4}$in.

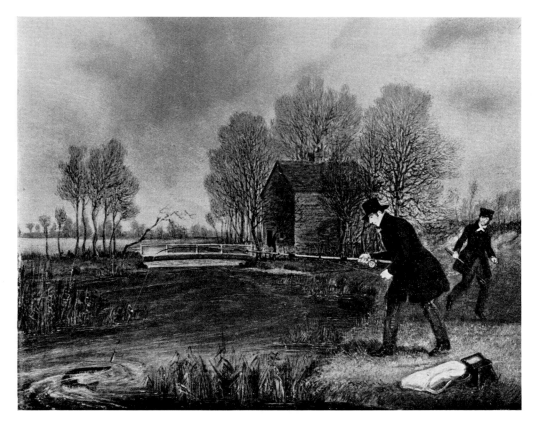

Cat. No. 365      PIKE FISHING ON THE RIVER LEA      10 × 12in.

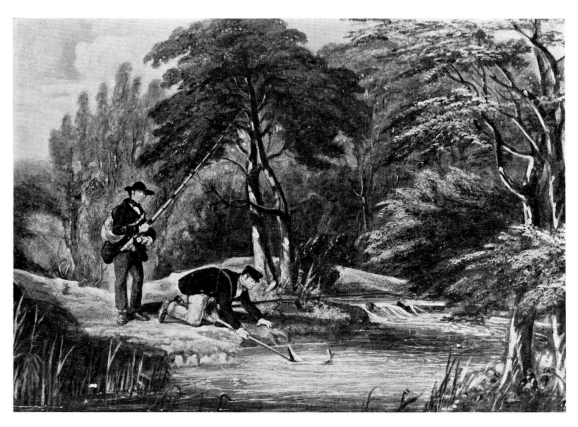

Cat. No. 364      PIKE FISHING AT HARLEYFORD-ON-THAMES      11 × 15in.

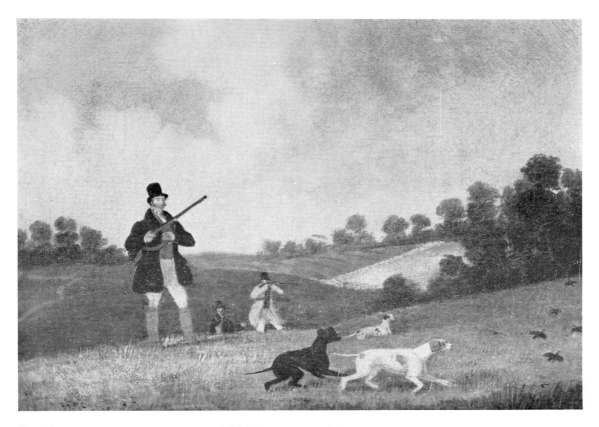

Cat. No. 355  PARTRIDGE SHOOTING  10 × 14in.
*In the Walker Art Gallery, Liverpool*

Cat. No. 353  JAMES POLLARD WITH HIS 18-YEAR-OLD SON JAMES ROBERT  9 × 11½in.
AND A COMPANION 'COUNTING THE BAG'
*In the possession of Mr. N. C. Selway*